MINNESOTA MOXIE

TRUE TALES OF
COURAGE, MUSCLE & GRIT
in the Land of
TEN THOUSAND LAKES

BEN WELTER

THE
History
PRESS

Published by The History Press
Charleston, SC
www.historypress.net

First published 2016

Manufactured in the United States

ISBN 978.1.46713.571.9

Library of Congress Control Number: 2016932970

CONTENTS

Contents

INTRODUCTION

The native peoples and immigrants who settled Minnesota were a tough lot. Blizzards, tornadoes, floods, drought, famine and disease took a heavy toll. But these challenges made our ancestors stronger, ready to face the stiffest test with determination and grace.

Inspiring stories are not hard to find. Many are preserved in the pages of Minnesota newspapers dating back more than 150 years. As an editor at the *Star Tribune*, I began combing these archives in 2005 in search of material for my blog, "Yesterday's News" (www.startribune.com/yesterday). In 10 years of blogging, I have posted hundreds of stories and more than one thousand photos and illustrations. Fresh interviews, background research and reader recollections flesh out many of the posts.

Minnesota Moxie, the third book based on my blog, is a collection of stories of strength, courage, tenacity and grit. These newspaper accounts are presented in their original form, along with photos from the archives of the Minnesota Historical Society, Hennepin County Library Special Collections, the Library of Congress, the University of Minnesota, the Memphis Public Library and the *Star Tribune*.

The lion's share of the credit for this volume goes to the skilled, enterprising and mostly anonymous reporters and photographers who originally covered these stories. Credit also goes to the sharp-eyed editors on the *Star Tribune* copy desk—most notably Vince Tuss, Catherine Preus, Holly Collier Willmarth and Pam Huey—who checked my raw blog posts. They caught countless errors and offered excellent suggestions on titles, captions and research.

I dedicate this book to my own ancestors, who emigrated from Germany and Luxembourg in the nineteenth century. The Welters, Sinnens, Scholzes and Theises carved out better lives for themselves and their children. And they enriched Minnesota with their work ethic, faith, values and customs.

It is fitting to share one family tradition here. My parents, James and Mary Ann (Scholz) Welter, grew up during the Great Depression. In the 1970s, they revived from memory a German recipe that reflects the hardy, waste-not, want-not spirit of the immigrant. If you can make this—and eat it—you can meet any challenge.

German Liver Sausage
Makes forty pounds

7 pounds lean hamburger
5 pounds liver
16 cups onion, chopped
10 pounds pig hocks
20 pounds pork loin

For the Seasonings:
7½ tablespoons salt
10 teaspoons sage
7½ teaspoons black pepper
5 teaspoons basil
3¾ teaspoons ground allspice
3¾ teaspoons ground cloves
3¾ teaspoons marjoram
2½ teaspoons dry mustard
2½ teaspoons thyme
5 leaves crushed rosemary

Fry the hamburger and liver.

The onions can be fried or cooked with the hocks and the loin. We cook the hocks and loin in the oven using plastic turkey-roasting bags—the meat in the bags and the bags surrounded with water in covered roasting pans.

Roast for about 5 hours at 325 degrees Fahrenheit. (For a smaller recipe, roasting time would be less.) The meat inside

the bags should reach 200 degrees Fahrenheit. When done, the meat should fall off the bones.

Debone and grind the meat and onions.

Mix seasoning together in a cup. Pour half the spices over the meat and sprinkle with water. Mix and repeat with the remainder of spices. We put all the juice from cooking the meat back in the sausage.

We do not use casings. We store the sausage in plastic bags and boxes in the freezer. They last for three months.

JIM AND MARY ANN WELTER
Richfield, Minnesota, 1986

JOHN L. SULLIVAN'S SLUGGING SHOW

NOVEMBER 27, 1883 *DAILY MINNESOTA TRIBUNE*

In November 1883, heavyweight boxing champion John L. Sullivan brought his touring band of "noted pugilists" to St. Paul's Market Hall for an exhibition of man-size action. Sullivan made quick work of a St. Paul man who had the courage to challenge the Boston Strongboy for a $500 prize. The Daily Minnesota Tribune *reported that the fighters wore white stockings, pink knee breeches and gaiters—but didn't mention gloves.*

An immense crowd gathered in Market Hall last night to witness the boxing exhibition given by [John L.] Sullivan and his company of noted pugilists. The audience was of the mixed variety that usually greets such a performance, ranging from the prominent business man down to the "rag-tag and bob-tail." Frank Morden was master of ceremonies, and first introduced Mike Gillespie of Boston and Taylor, "ex-champion of the world." The contestants were dressed in regular ring costume with white stockings, knee breeches and gaiters. Above the waist they wore bare.

The next set-to was not on the program, and was an unexpected treat to those present. It consisted of a contest between Morris Hasey and Sullivan, the former having expressed a desire to stand up four rounds before Sullivan for the standing prize of $500. Sullivan appeared in fine condition, strong, active and wiry as a squirrel. He was dressed in pink knee breeches, white stockings and gaiters. He turns the scales at 226 pounds. Hasey, a resident of St. Paul, a six-footer weighing 195 pounds, muscular and well formed, but bearing no comparison to the champion.

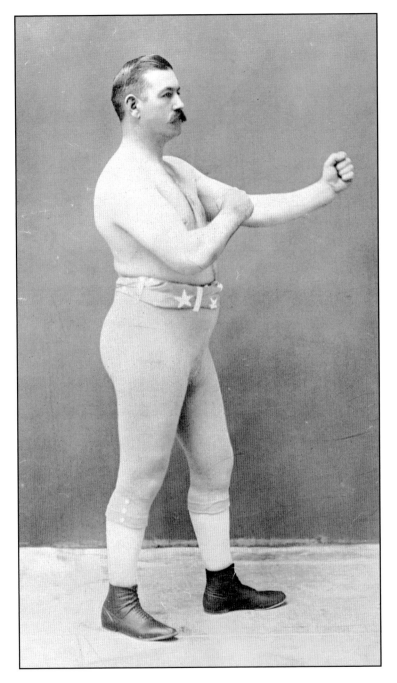

John L. Sullivan returned to Minnesota in 1887 to fight Patsy Cardiff at the Washington Roller Rink in Minneapolis. Sullivan suffered a broken left arm in that bout but managed to fight to a draw. *Library of Congress.*

He is a stationary engineer by trade. Time was called and no sooner had Hasey toed the scratch than Sullivan stretched out his arm and Hasey fell on the stage as if struck by an axe. He exhibited nerve, however, and desired to test his powers again, but as soon as he got within reach the champion knocked him over like a flash. He fell against the stage, and uttered a gasp or two and it was evident that he had had sufficient. Sullivan then addressed the audience and told them that Hasey had been boasting about how long he could "stay" with him. "You see how long he has done it," the champion slugger said.

The next contest was between Herbert Slade, the Maori, and Pete McCoy, the lightweight champion. The four rounds were characterized by quick hitting and fine sparring. Following this came a set-to between Steve Taylor and "Prof." Donaldson of Minneapolis. Taylor made short work of Donaldson, vanquishing him in the first round. Taylor then boxed four rounds with Sullivan, during which much science and nerve was displayed. A contest between McCoy and Gillespie followed and the entertainment wound up with a four-round set-to between Sullivan and Slade, during which much pretty work was done, although it was evident that Slade was no match for Sullivan.

ICE HARVEST ON CEDAR LAKE

January 24, 1890 *Minneapolis Tribune*

Bundle up, dear reader, and join a Tribune *reporter for a behind-the-scenes look at the Cedar Lake ice harvest of 1890. The process required plenty of muscle from both man and beast. This eyewitness account includes enough detail to guide an artisanal revival of the craft in the twenty-first century. But I had to look up one unfamiliar term. The "Sam Joneism" mentioned in the first paragraph is a reference to Samuel Porter Jones, an itinerant southern preacher of the period best known for his admonition: "Quit Your Meanness."*

THE CRYSTAL HARVEST
THE ONE AND ONLY MINNESOTA CROP WHICH IS NEVER A FAILURE
HOW ICE IS TAKEN FROM THE LAKES AND STORED IN HOUSES.

There is one crop in Minnesota that never fails. Chinch bugs cannot eat it, rust has no effect upon it, and the cyclone fails to level it to the ground. To use a Sam Joneism, "a fellow can bank on it." It is scarcely necessary to remark that the ice crop is meant.

Occasionally the winter is sufficiently mild to prevent St. Paul from building an ice palace, but never in the history of the state has the iceman failed to reap an abundant harvest. The only thing the average citizen can't quite understand is why, when the climate produces such a plentiful supply of the commodity, he is unable to get a larger chunk of it for his money during the dog days. This is doubtless a question which will never be answered on this side [of] the pearly gates.

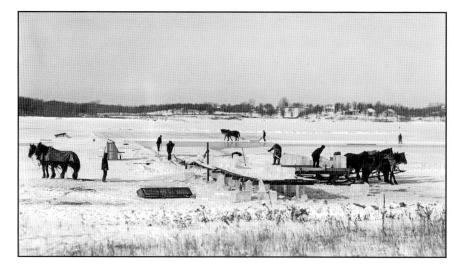

Ice harvest on Cedar Lake, about 1910. *Minnesota Historical Society*.

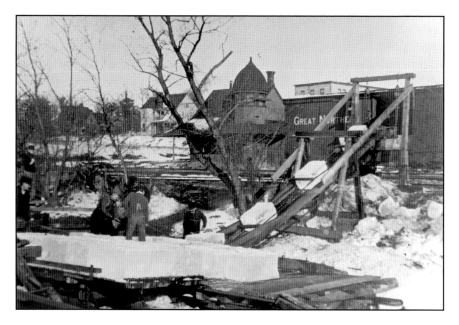

Workers loaded ice blocks onto a train at Kenwood Station in Minneapolis in about 1900. *Hennepin County Library Special Collections*.

In Minnesota the ice harvest generally begins in January and lasts about six weeks, although some firms extend the season to two months or more in order to give employment to their men as long as possible. The present season thus far has been very favorable for the dealers. The cold weather came on early enough to make a good coating of ice on the surface of the lakes and rivers, so that work could begin early in the present month. As a rule the dealers do not care to harvest ice that is less than [sic] 16 inches thick, and a few years ago that thickness was not considered sufficient.

The great bulk of ice used in Minneapolis is taken from the surrounding lakes. What is cut from the river is delivered only to butchers and others who use large quantities for coating purposes. Private families, hotels, restaurants and the boarding houses are served with lake ice.

The four leading firms who deal in the crystal product are the Cedar Lake Ice Company, H. Westphal, the Boston Ice Company and J.W. Day. These are given in order of the business transacted. The yearly product is close on to 150,000 tons, and the cut this season will probably somewhat greater than usual. As a rule all the ice cut at Minneapolis is used to supply

THE HOME MARKET.

Occasionally orders are received from outside points. Southern dealers generally cut their own ice in some of the Northern States rather than contract it from local firms.

Notwithstanding the fact that ice is such a plentiful commodity in Minnesota, comparatively few people understand the modus operandi employed in harvesting it. In order to furnish information for this larger class a *Tribune* reporter accepted an invitation from Mayor E.C. Babb yesterday to take a drive to Cedar Lake and witness the operations of the men employed by the Cedar Lake Ice Company, of which the mayor is president.

Seated beside the mayor in his covered family sleigh and comfortably wrapped up in warm robes, the scribe was driven out to Twenty-eighth street, thence across Lake of the Isles, through Kenwood to Cedar Lake. Here a busy scene met the eye. Many men were employed, some in cutting the product, others in skidding it up an inclined plane on to large platforms, and still others were loading it on to sleds to haul it [to] the ice houses. It is well to explain at this point that the company has several ice houses, situated in different parts of the city. It considers it more convenient to distribute the ice from these scattered centers than from one cluster of houses on the lake shore. It has one large house at Lake Calhoun, which will not be filled until after the others.

The first thing to be done in beginning the harvest is to clear the ice of snow, if there be any. A straight line is then made on the surface of the ice, and the "marker" started. This is a machine having handles like a plow. Attached to the lower end of the handles is an iron bar about six feet long, to the under side of which are attached knives somewhat resembling saw teeth. Each tooth has a heel at the rear which allows the tooth to sink into the ice a quarter of an inch. Each succeeding knife is placed directly behind the one in front and is a quarter of an inch longer. It is thus readily seen that the depth of the groove is found by multiplying one-fourth of an inch by the number of teeth.

The marker marks a groove two inches deep. When a groove has been made the desired length, the marker is reversed. A thin piece of steel parallel to the bar bearing the knives, and which can be set at any desired distance from it, is placed in the groove already made and the return trip made. A new groove is thus made at each trip. The grooves are made 22 inches apart one way and three feet apart the other. This gives a block of ice three feet long and 22 inches wide, the thickness being regulated by Jack Frost. The marker is drawn by a team of horses. After the ice has been marked, an implement similar to the marker and propelled by the same power,

But Whose Knives

are 12 inches long, and on which there is no guide, is used to deepen the groove. As it sinks to two inches each trip, five trips are required to make the grooves the requisite depth. An opening is then made with saws and the blocks hauled out. When a long and narrow opening has been made, large cakes containing 100 blocks are detached at a time. A man armed with a weapon which is a cross between Neptune's trident and a large garden fork, then leaps nimbly upon the large cake, and by thrusting his weapon into the deep groves, dexterously and rapidly splits them up into blocks. An experienced hand will easily break up a 100 block cake in five minutes. The blocks are then guided through a narrow sluiceway in the ice by men armed with an implement resembling a lumberman's pick. Here they are run up a short incline by means of horse power and pulleys. When the top is reached the blocks slide down another incline to a platform, where they are loaded. Four of these blocks are estimated to weigh a ton, and the teams haul from 16 to 20 blocks at a load. The company is now employing about 50 teams.

When the teams arrive at the ice house, the ice is unloaded on to a platform and raised perpendicularly by steam lifts into the building. These lifts easily raise

Alfred Hilgers Sr. of Spring Park muscles an ice block onto a truck on Cedar Lake in Minneapolis in January 1947. *Minnesota Historical Society.*

four tons in 1½ minutes. With the force of men now employed the company can store 1,000 tons per day. When the blocks enter the building gravity sends them spinning along runways in different directions. Workmen then seize them with picks and place them in tiers one upon another, where they will remain until doled out in microscopic bits to customers next summer.

This plan of operation is the one employed by most of the larger ice companies. The smaller firms run the blocks up inclined planks into the houses, and this plan is often adopted when the houses are situated on the banks of the body of water where the ice is harvested.

The ice harvest is now booming all along the line. To stand in one of the immense houses chills one to the marrow. The only thing that makes him at all comfortable is the thought of the refreshment he may receive next summer from an elegant lemonade cooling with a piece of one of the huge cakes that lay all around him. The ice that is now being taken out of the lakes is as clear as crystal and so pure that no typhoid germs lie concealed within. It would make a St. Paul man sick to look at it and reflect that his city decided not to have an ice palace this winter.

SCHOOLCHILDREN MOVE A HOUSE

May 29, 1896 *Minneapolis Tribune*

How many children does it take to move an old, decrepit house six miles? The answer, Minneapolitans learned back in 1896, was about ten thousand.

Two years earlier, a Minneapolis Journal *reporter had tracked down the oldest wood-frame house west of the Mississippi and proposed to have the city's schoolchildren team up to move the structure from its temporary address, 324 Sixteenth Avenue South, to Minnehaha Park, where the Stevens house would be preserved for future generations to enjoy.*

The newspaper solicited donations, added its own money and bought the house. It then organized the move with the support of the park board, the school board, the mayor and the streetcar company. On May 28, 1896, about ten thousand first through twelfth grade students got a day off from school to handle the big job. In seven relay teams, they latched onto ropes and helped ten horses pull the house down Minnehaha Avenue to a spot outside the park.

You can imagine the mayhem: thousands of largely unsupervised schoolchildren, armed with free trolley passes, loosed on the city. This story—from the competing daily, the Minneapolis Tribune*—was buried on page five. It captures the spectacle beautifully—without once mentioning the* Journal.

On the day of the big move, the *Minneapolis Journal* published dozens of stories previewing the event, accompanied by a series of charming sketches, including this one, at the bottom of nearly every page.

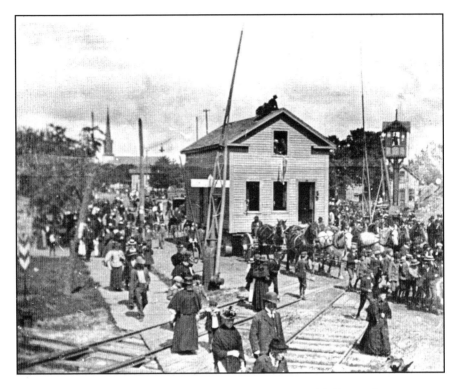

A team of ten horses helped get the parade in motion around 9:00 a.m. Star Tribune *archives*.

All Took a Hand
School Children Move the Old Stevens House.
The First Residence Built in Old Minneapolis Given a Final Site at Minnehaha Park—Enthusiastic Thousands of Grade and High School Pupils Join Hands in the Event—Rivalry Between the Central and South Side Schools Breaks Out in a New Place—Seven Relays Change About at the Task—Addresses Delivered at the Park.

Eight thousand school children from the grades and nearly 2,000 high school students took a long pull, a strong pull and a pull altogether, and after several hours of pulling landed the historical old Stevens house within the sound of the Laughing Waters of Minnehaha yesterday.

It was a gala day in the public schools and every student who was old enough and strong enough was given an opportunity to assist in the event, before the first house ever built in Minneapolis had finished its long journey

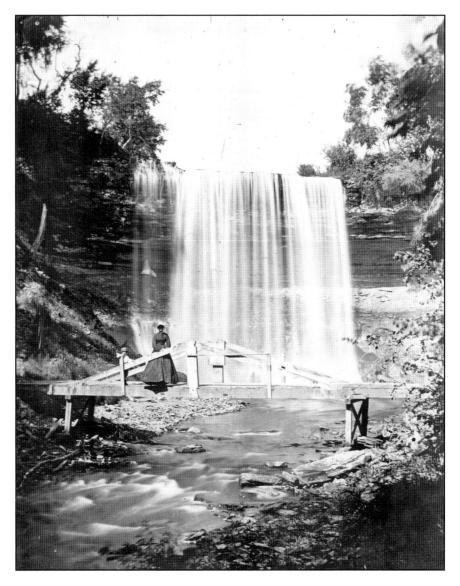

Minnehaha Falls, about 1900. *Hennepin County Library Special Collections.*

of some six miles, and had reached its last resting place, there to remain until its timbers have rotted with time.

Its final home is peculiarly fitting, as there are blended together in one story two histories, that of the first Indian and the first white man within the lines which now comprise the limits of Minneapolis.

21

The program passed off smoothly and successfully, and the thousands of people who crowded along the line of march cheered in enthusiasm as the homely, decrepit old house was pulled along the historical Minnehaha road.

The 10,000 pupils did not all pull at once. They were divided into seven relays, each successive division being taken to their respective station in trolley cars, and arriving just in time to take up the long ropes as they were dropped by the preceding relay. Two or three of the relays were somewhat late, owing to the crowded condition of the street, and the delay made the house arrive at the falls somewhat behind schedule time.

Yet for an affair of such magnitude, there were few unpleasant incidents and no accidents. Sergt. Martinson and eight officers from the South Side police detail looked after the children with painstaking care, and prevented any serious mishap. House-mover Pratt had already hauled the historical old building to the place of starting, at Sixteenth avenue south near Fourth street, and was in waiting at 9 o'clock for the first relay of children. With him were several linemen and electricians, who traversed the route to guard against accidents from wires.

Working in relay teams, thousands of schoolchildren—with help from 10 horses—pulled the Stevens House nearly six miles.

At 9 o'clock the corner named was surrounded by a great throng of shouting eager school children, all anxious to take hold of the big ropes which stretched out for 400 feet in front of the house. Every one was promptly on hand, and Supt. Jordan, of the public schools, and city officials looked anxiously for Col. John H. Stevens, whose hands fashioned the old building nearly a half century ago. But the sad intelligence was soon received that the venerable citizen, and the pioneer of the city, had been stricken with paralysis as the result of the excitement, and would be unable to attend. A committee was sent to offer condolence to the stricken man.

But the children knew nothing of the sad occurrence and were impatient to start on the novel journey. Contractor Pratt appeared in time with 10 strong horses and hitched the teams to the trucks. At a given signal a bugler from the state troops, clad in full regimentals, stepped between the lines of happy children and blew a merry blast. It was the order for "forward march," and there came a tremendous strain on the ropes. The old house shook for a moment, lurched a little, and then smoothly began its long journey. A lusty cry went up, which was taken by the spectators and repeated for a half mile along the line of march.

The first relay consisted of 1,100 children from the Clay, Jackson, Peabody, Corcoran, Irving, Greeley, Washington, Madison and Motley schools. They

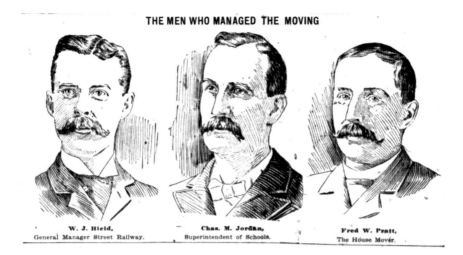

THE MEN WHO MANAGED THE MOVING

W. J. Hield,
General Manager Street Railway.

Chas. M. Jordan,
Superintendent of Schools.

Fred W. Pratt,
The House Mover.

The *Minneapolis Journal* offered exhaustive coverage of the move, including profiles of three men who played key roles. Star Tribune *microfilm.*

Minneapolis Central High School, 1902. *Hennepin County Library Special Collections.*

pulled the house to Franklin and Minnehaha avenues, where the ropes were dropped and a rush made for waiting trolley cars.

With equal impetuosity the second relay jumped into line, and after a short pause the house was off again. This time the Longfellow, Rosedale, Clinton, Whittier, Bryant, Sumner and Lincoln schools were pulling and tugging at the rope. Everything went smoothly, and at Twenty-sixth street the relay gave way to another from other schools.

At this point there was something of unexpected interest. Waving their school flag in triumph from the gable window of the old building the lads from the South Side High School shouted their school yell and

Bade Defiance To All Comers.

At this point, the Central High School scholars were billed to relieve the South Siders and, consequently, surrounded the building.

The spirit of school rivalry broke out, strong and bitter. The South Siders refused to surrender the fortress and flaunted their banner from the window in spite of all entreaties and orders. Contractor Pratt could not oust them. Supt. Jordan could not oust them, and finally Sergeant Martinson called for a detail of police and made a rush for the house. But the South Side lads were still game, and did not give up until several had been made to feel the force of police authority. Then they made a break. As they dashed from one door the Centrals entered by the other, and their banner was soon flying from the gable amid vociferous cheers. The South Siders were chased up the street by a detachment of Centrals, and for a moment it looked as if the rush would result in some bruised heads. However, good nature was restored and again the house started on its way. There was no hitch in the proceedings, and at 1 o'clock the house had passed the Minnehaha Driving Park. As each relay finished its work it was carried to the park, there to await the formal ceremonies in the afternoon.

The site for the building had already been prepared and the house was hauled to it rather late in the afternoon. The entire distance covered by the different relays was about four miles.

At Its Destination.
The house arrived at the park a little after 3 o'clock [and was] brought to the spot that it will occupy in the years to come. An impromptu platform was erected in front of the old doorway, from which the speeches were delivered in the presence of the many that gathered around.

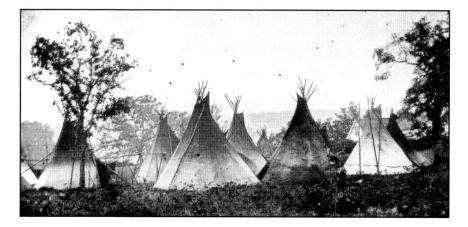

The roof of the Stevens house is visible behind the tepees at right in this photo from about 1854. *Hennepin County Library Special Collections.*

Ald. Frank B. Snyder, who was born in the house, presented it to the city.

"It is both fitting and proper," said the speaker, "to glorify the relics of bygone days. I remember the house as it stood amid the lilac bushes beneath the foliage of overhanging trees on the green banks of the Mississippi. Many changes have come since then, and the old landmark was swept away. The old house has no commercial value, but only stands as a monument of the past. Old Home! I greet you. You are endeared to me by memories of the past. For many years you have been an outcast, forsaken, neglected, almost forgotten, I rejoice that at this late day, there has come to you, as to an old man, a second childhood: that henceforth as of old, you will nestle on the green banks of a flowing stream, beneath the foliage of overhanging trees, and that you will again feel the mist and hear the roar of the falling waters. Mr. Mayor, in behalf of the children who have brought this old building here, I now transfer the first house build in Minneapolis, to you, by delivering the key, to have and to hold, for the use of the public, from this time forth, forever."

Mayor Pratt accepted the house in the following words:

"Honorable President of the City Council—I have the honor and pleasure, on behalf of the city of Minneapolis, to receive from you, representing the press and the school children of this city, this historic house—historic, because it was the first house built upon the site of our great and beautiful city.

"It has been a silent witness to a transformation more marvelous than any conjuration of Aladdin's lamp. Forty-six years ago it stood alone on the border of a trackless prairie, on the west bank of the Mississippi, on the very spot that is now the center of the industrial and commercial life,

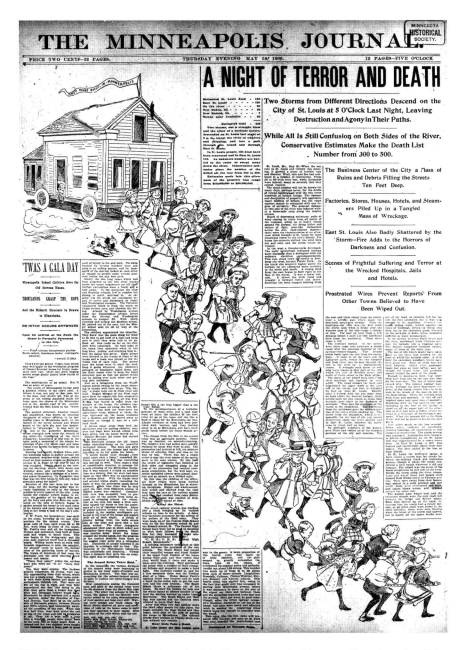

The *Minneapolis Journal* devoted much of its front page to the big move, featuring a fanciful illustration of children pulling the house—and the tragic news of a killer tornado in St. Louis. Star Tribune *microfilm.*

not only of a great city, but also of that vast tributary region of which we are the metropolis. Forty-six years ago, a solitary house, hundreds of miles from any railroad; today, a railroad center, whose gigantic arms reach from sea to sea.

"Then it stood in a region inhabited only by savages. Now, in their place, are churches, schools and thousands of Christian homes…"

His honor waxed on for several more minutes, quoting a passage from Longfellow's "Song of Hiawatha" and praising the city's "wonderful progress" before, at last, introducing the parks commissioner, Prof. W.W. Folwell, who waxed on for several minutes himself, finishing with a call to greet the old home "with a mighty hurrah."

The hurrahs were given with a will, after which the South Side High School brought out yells for the different personages who had each taken party in the exercises.

As each relay was released, the children took the next car and rode to the falls. They had all been given souvenirs that insured them a free ride, and soon the part was one mass of children. They were everywhere. There was not a spot in the large park that they did not visit; the falls, looking down at the water as it struck the waters below; down through Longfellow Glen they thronged like so many "Brownies." At the Soldiers' Home they made themselves perfectly at home, and here they received a cordial welcome, and were shown everything that could be of interest. They had all taken lunch baskets, and by noon the whole park was a large picnic ground. Many of them became so absorbed in the different things that were to be seen that they paid no more attention to the old house after they were once at the park. Many, however, became so interested in the old landmark that they followed every move it made, lustily cheering it as, creaking, it slowly moved towards its

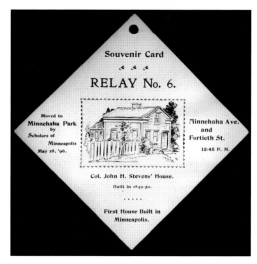

Souvenir cards identified members of each relay team and served as trolley passes.

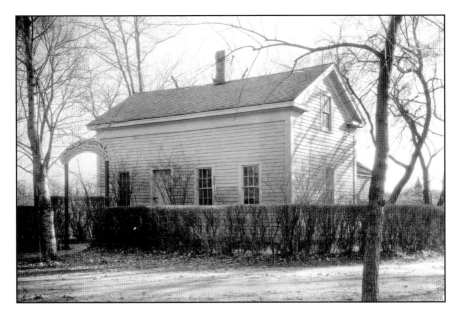

The Stevens house in 1934. *Library of Congress.*

last resting place. Many of the children began to leave as soon as the exercises were over, but it was nearly dark before the last little curiosity seekers, tired, turned their footsteps homewards to seek their beds and dream of how the little fairies had drawn the old Stevens house out to Minnehaha Park.

At 8 o'clock last evening the railway gave an exhibition of fire works at the Falls, which in effect has never been equaled in this part of the country. The falls itself was the object worked upon, and the result was more than human mind can comprehend without seeing it. Colored lights were placed on the rocks immediately behind the falling water, at the sides and at the bottom. Calcium lights were thrown on the water, giving the falls the appearance of a sheet of fire, and increasing the volume about six times. Fully 1,000 Japanese lanterns were strung through Longfellow glen, thereby adding to the romantic beauty of the whole.

HANDLED THE CROWD WELL.

The Twin City Rapid Transit Company deserves considerable credit for the manner in which it handled the school children yesterday. The scholars were all given badges which entitled them to free rides in the cars and the youngsters improved their opportunity all day long. Not content with riding

to Minnehaha Falls and back, they put in extra time riding about the city, some traveling on as many as five different lines.

Altogether the company carried about 10,000 children. Nearly all went to the Falls after they were through pulling the Stevens house, and the majority remained there until late in the afternoon. The time limit was supposed to be eight o'clock, but there were many children who did not leave the Falls until after that hour. The rain in the afternoon helped out wonderfully, as it started the crowds toward the city, and there was not such a crush later on as there would have been but for the rain. The company had no trouble in handling the children and there were no accidents.

CRITICISM FROM VARIOUS SOURCES.

Yesterday's event did not pass off without certain criticisms from various sources, and for various reasons. There were many parents who objected to sending their children out on such an excursion through anxiety lest something should happen through the day, and yet they felt as if they were called upon to do so on account of the way in which the matter had been put before the public. There were mothers who have no children, but who are interested in educational matters, and who think that there are enough holidays for the children, without an extra day being given them. If such an event was to take place it was their opinion that it should take place on some regular holiday instead of breaking in on the regular school routine. Then the park commissioners and the park policemen objected to the way in which the children took possession of the park and everything in it. There was no such thing as controlling them, and they ran over everything in sight. It would have taken a small regiment of policemen to have kept that throng in check.

STRICKEN WITH PARALYSIS.
COL. J.H. STEVENS TEMPORARILY OVERCOME BY EXCITEMENT.

Col. John H. Stevens, whose continued good health, although he has arrived at a very advanced age, has been a pleasing commentary on the salubrity of Minnesota's climate, suffered a slight stroke of paralysis yesterday. He passed a restless night, being in a somewhat excited state of mind presumably on account of the popular demonstration in connection with the moving of his first Minneapolis home. Early in the morning, shortly after arising, he was afflicted with a paralytic stroke which for a time

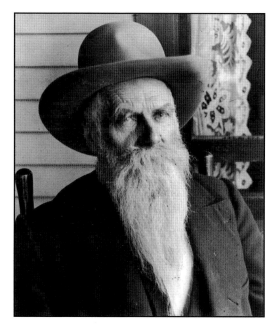

Colonel John H. Stevens, who built the house in 1849–50, suffered a stroke of some kind and was unable to take part in the festivities. *Hennepin County Library Special Collections.*

prostrated him completely, rendering him powerless to move a muscle in the entire right side of his body. His physician was called and rendered prompt assistance, and within a short time his condition was considerably relieved.

SPOKANE TO NEW YORK ON FOOT

JUNE 2, 1897 *MINNEAPOLIS TRIBUNE*

For Helga Estby, a thirty-six-year-old Norwegian immigrant, wife and mother of eight children, 1896 was a very tough year. The economy in eastern Washington had soured. Jobs evaporated, businesses closed and families struggled to survive. Her husband was out of work, and their 160-acre farm outside Spokane was on the verge of foreclosure.

Sometime during these difficult months, Helga learned that a "wealthy woman" in New York or other "eastern parties" were willing to pay her and her teenage daughter Clara $10,000 if they would cross America on foot, unescorted, and complete the journey within seven months. The pair accepted the challenge and set out on May 5, 1896, armed with little more than $5 each, a revolver, red-pepper spray and a curling iron for Clara's hair.

Their 3,500-mile trek is the subject of a fascinating book, Bold Spirit: Helga Estby's Forgotten Walk Across America *(2005), by Linda Lawrence Hunt. The journey also inspired a young adult novel,* The Year We Were Famous *(2011), by Helga's great-granddaughter Carol Estby Dagg.*

The mysterious "eastern parties" never paid up, and Helga and Clara, short on cash, were stranded in New York for the winter. A Minneapolis Tribune reporter interviewed them as they passed through Minneapolis on their way back to Washington. A clipping of this article, preserved almost by accident by the family, rekindled interest in the women's remarkable story more than a century later.

Women Walkers

They Travel on Foot from Spokane to New York City.
Left Home May 5, 1896, and Reached New York Dec. 3—Were to
Have Received $10,000 If the Feat Was Accomplished by Dec. 1—Are
on Their Way Home Again and Arrived in Minneapolis Yesterday—
Speak Entertainingly of Their Trip to the *Tribune*—Passed Through
Many Uncomfortable Experiences and Had Many Narrow Escapes
from Death—Will Remain in Minneapolis for a Short Time.

Mrs. Helga Estby and her daughter, Clara Estby, of Spokane, Wash., who last year performed the marvelous feat of walking from Spokane to New York city, arrived in Minneapolis last evening on their way home, and are at present at the Excelsior-Scandia house. They came from Chicago, which city they left May 5.

The women left Spokane May 5 last year at the instance of private parties in New York, who offered them $10,000 if the feat was successfully

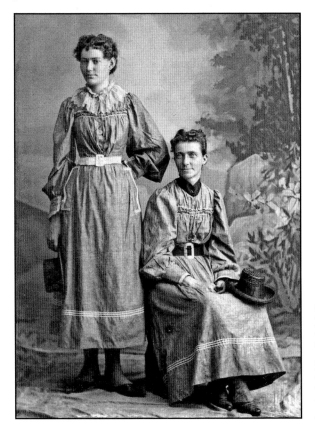

Clara (left) and Helga Estby sat for photos during their stop in Minneapolis. The Estby family lived on a farm in Canby, Minnesota, for eleven years before moving to the Spokane area in 1887. *Bahr family collection.*

accomplished by Dec. 1 the same year. In the contract made was a provision which took into consideration sickness, but accidents were overlooked. The travelers reached New York Dec. 3, three days behind time, which was owing to the fact that Miss Estby had her ankle sprained in Pennsylvania. The matter was finally satisfactorily adjusted, and the women will receive $10,000 when the book, written by them and describing their travels and adventures, is completed.

When seen by THE TRIBUNE last evening, they presented a very home-like appearance. They had modestly made themselves comfortable in the kitchen at the hotel, and were busy telling their story to the proprietor and waiters of the place. The mother, who is 37 years old, is of somewhat slender build, but has rosy cheeks. The daughter, who is 19 years old, looks more like a maiden in some of the rural districts of Europe than an American girl. She appears in the vigor of health-budding womanhood. Both are apt talkers, and, although of Scandinavian birth, speak the English language fluently and entertainingly.

Mrs. Estby essayed the part of spokesman. "We left Spokane May 5, a year ago," she said. "We took the Union Pacific track from our starting point to Denver, whence we followed the Burlington to Omaha. Here we took to the Rock Island to Chicago. In Pennsylvania we followed the Harrisburg & Reading, and which led us into New York. We walked 4,600 miles, and have touched 13 different states in the Union. The average number of miles covered during the day was 27½, but we have traveled 50 at times. During our travels we have worn out 16 pairs of shoes, eight hats, and have now on our fifth costumes.

"You must not suppose that our travel was one of pleasure entirely. When we left Spokane we had only $5 each, which was of course soon spent. From then on until we reached New York we had to work for what we got. Sometimes it was very hard, and we have often gone with but one meal a day. We got along comfortably when we only got two meals. We have encountered all kinds of weather, snow, rain, electric storms, hurricanes. In Wyoming we had a narrow escape from a mountain lion, while in Colorado we experienced the dangers of the rattlesnake. At one time we got into a cloudburst, and it was only by holding onto shrubs that we escaped with our lives.

"At one time we had some trouble with the Indians. That was in Utah. They took our small satchel and went through it, but oddly enough, the only thing they found that they thought they could make use of was our curling iron. This puzzled them very much, and we had to demonstrate its use.

"We have done about all kinds of work except saw and split wood. Of the different states that we passed through we had the most trouble in Pennsylvania. There the Italians working in the coal mines were troublesome."

The women exhibited a document signed by Mayor H.M. Belt, of Spokane, chronicling the object of the tour, and recommending them to any they may come in contact with. This was also signed by President William McKinley, Mrs. William Jennings Bryan, Gov. F.M. Drake, of Iowa; George E. Swift, ex-mayor of Chicago; Gov. W.W. Wells, of Utah; Gov. W.J. McConnel, of Idaho; Gov. Daniel Hastings, of Pennsylvania, and Gov. Albert W. McIntyre, of Colorado.

YOUNG BICYCLISTS TOP 10 MPH —AND LAND IN JAIL

May 21, 1899 *Minneapolis Tribune*

Bicycling was booming in the 1890s, fueled by improved bike design and demand for cheap transportation. In the wrong hands, however, the new "safety bike" was anything but. Careless young "scorchers" pedaled furiously up and down urban streets, startling horses and pedestrians alike. Newspapers of the era regularly reported collisions that resulted in serious injuries and, on occasion, death. Across the country, bicycle speed limits were established to protect the population. In Minneapolis, the speed limit was ten miles per hour. And police were serious about enforcing the law.

CAUGHT HIM SCORCHING
POLICE CAPTURE THREE YOUNG MEN WHO VIOLATED AN ORDINANCE. THEY COULD NOT RESIST THE TEMPTATION TO INDULGE IN A SPIN ALONG PARK AVENUE LAST EVENING.

It might have been a picnic party judging from the high spirits of the three lads who were enjoying an expensive ride in the patrol wagon last night.

"Scorching again, old man," cried one of the prisoners, as the patrol wagon turned into lockup alley, and a curious crowd "rubbered" as if their necks would be stretched off.

"He certainly was good to me," said another, and the crowd laughed.

But when the iron bars shut out their view, and the youthful trio had nothing but whitewashed walls to gaze at, they began to realize their doom, and the minutes of their imprisonment began to grow into hours, at least so it seemed to them.

The smooth asphalt of Park Avenue was an attractive route for Minneapolis cyclists in 1899. *Hennepin County Library Special Collections.*

It was an ideal evening for a spin. Of course it was a little chilly, but then a spurt of a block or two helped to warm the blood. And that asphalt on Park avenue was so tempting. Who could help but ride fast just a short distance?

That is where the boys made a mistake. There was a mounted policeman— that is, he was mounted on a bicycle—watching them, and he could scorch a little himself. While the boys were tearing up the pavement he was after them, and as they slowed up a little for a breathing spell, he cut across them into the curb and they had to come to a stop.

"Well, boys, you are my prisoners, so just come along," said Officer Fred Williamson, as he mopped the perspiration off his forehead and gave his wheel an admiring glance.

The policeman and his prisoner walked up Twenty-fourth street to the patrol box at Fifth avenue, and the patrol wagon was called. A crowd of wheelmen had gathered, and they joked both with the officer and the lads.

As the last of the trio of alleged scorchers was hustled into the wagon with his wheel, he issued the following challenge to the policeman:

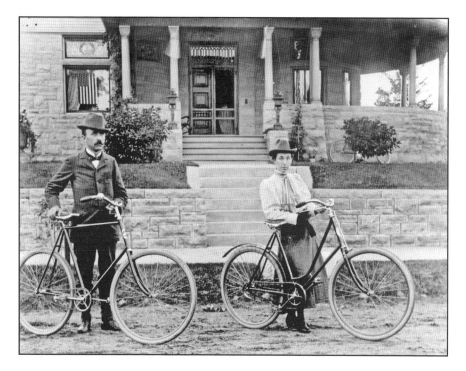

A man and a woman show off their wheels in front of the Wallof house, 2200 Sheridan Avenue South, Minneapolis, in 1898. *Hennepin County Library Special Collections.*

"I'll bet, officer, I can beat you in a 100 yard dash," but Williamson was busy by this time cleaning the mud off his machine.

On the way to the station the prisoners had a happy time, and they did not mind the "scorching" remarks made by passing bicyclists.

The boys gave their names as Frank Gardner, Guy Smith [and] Clarence Hanson, and they will plead to the charge of exceeding the ordinance speed limit of 10 miles an hour. The oldest of the trio is only 18, while the other two are less than 15 years. They belong to good families, but the police use no discrimination when they are after fast riders.

"Well, I don't know how I'm going to get out tonight," woefully said one of the younger boys. "My folks are all out of town."

HOW TO MOVE 120 TONS OF BRIDGE

October 20, 1899 *Minneapolis Tribune*

Over the past 150 years, five bridges have spanned the Mississippi River at Wabasha Street in St. Paul. The first, a wooden Howe truss span known as the St. Paul Bridge, was completed in 1859. The second, built in 1872, was of the same design. The third, built in about 1884, has been described as a Whipple double-intersection Pratt, an innovative version of the all-iron Pratt truss. Innovative, perhaps, but not enduring. Five years later, work began on an iron cantilever deck-truss that served the city for a century before the high cost of maintenance and repair spelled its doom. The current Wabasha Street Bridge, a concrete segmental box girder bridge, was completed in 1998.

The fourth bridge was built in two parts, first the north section beginning in 1889 and, ten years later, the south section. The latter project required that a 120-ton span of wood and iron be moved fifty feet, from temporary wooden piers built downstream to permanent masonry piers. In the story below, the Tribune *explained how six men, without the aid of horses or steam power, completed the job in just eight hours.*

BRIDGE MOVING BY MODERN METHODS

Six men moved the 120 tons of wood and iron contained in one span of the Wabasha street bridge, St. Paul, 50 feet Wednesday, and they didn't make much fuss about it as an expressman would in getting a trunk upstairs. The men were not unusually tired after their feat, for screws and compound levers accomplished what their hands could never have done and completed a task in which it would have been dangerous to have used machinery.

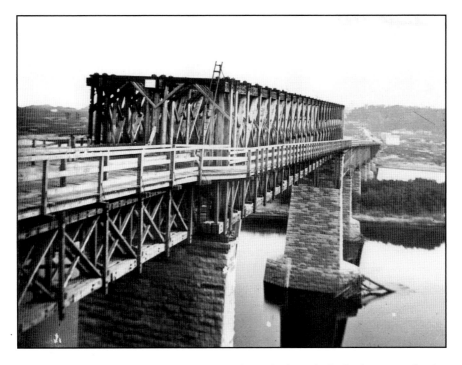

The first bridge to span the Mississippi River at Wabasha Street in St. Paul was completed in 1859. *Hennepin County Library Special Collections.*

By the aid of screws and rollers the men pulled the bridge the entire distance in eight hours. The lifting and trussing of the bridge requiring a week or more, and it will take almost that long for each of the other two spans that will have to be moved. After all this is done the approaches will have to be shaped up and the connection made with the permanent portion of the bridge.

An attempt was made at first to move the bridge without the use of rollers, but it was found the friction was too great and that it could not be done. The rollers are simply iron bars cut in short sections, and as fast as they roll out from under the plate they are placed in front again. A screw mechanism is employed at each end of the span. In moving the bridge it is necessary to exercise the greatest care to avoid demolishing the old piers.

The contract for moving the old bridge amounts to $7,500 and for building the approach $40,995.

BITTEN BY WOLF, ACTRESS FINISHES SHOW

OCTOBER 21, 1903 *MINNEAPOLIS TRIBUNE*

A sleeping teenager was bitten by a wolf while camping near Lake Winnibigoshish in 2013. News reports described it as the first documented wolf attack in Minnesota history. Not true. More than a century ago, the Minneapolis Tribune *documented a wolf attack in, of all places, the Bijou Theater on Washington Avenue. Sounds like it was quite a show.*

FIGHTS FOR HER LIFE
ACTORS IN QUEEN OF THE HIGHWAY ATTACKED BY WOLF.
BEAST ESCAPES FROM HIS CAGE WHILE PERFORMANCE IS IN PROGRESS.
DASHES INTO YOUNG WOMAN'S DRESSING ROOM AND ONLY TIMELY ARRIVAL
OF ANIMAL TRAINER AND GREAT DANE DOG SAVES HER FROM SERIOUS
INJURY AND POSSIBLY DEATH.

In an encounter with one of the wolves which had escaped from his cage, Miss Charlotte Severson of the Queen of the Highway company, was badly bitten last night, and it was only by a great deal of pluck that she finished the play out.

During the third act, when Bob comes charging down an incline on his pony, the pony bucked and raised such a clatter that the wolves became frenzied, and Moko, the largest and fiercest of the lot, escaped and went charging around the rear of the stage in a mad career of fright.

The audience heard the barking and howling, but took it for part of the play and did not know that the brute had attacked Miss Severson in her

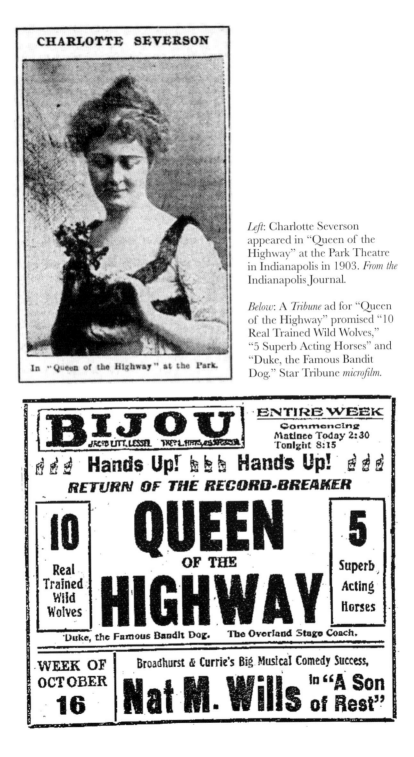

CHARLOTTE SEVERSON

In "Queen of the Highway" at the Park.

Left: Charlotte Severson appeared in "Queen of the Highway" at the Park Theatre in Indianapolis in 1903. *From the Indianapolis Journal.*

Below: A *Tribune* ad for "Queen of the Highway" promised "10 Real Trained Wild Wolves," "5 Superb Acting Horses" and "Duke, the Famous Bandit Dog." Star Tribune *microfilm.*

BIJOU
JACOB LITT, LESSEE FRED'L. HITE, MANAGER

ENTIRE WEEK
Commencing
Matinee Today 2:30
Tonight 8:15

Hands Up! Hands Up!
RETURN OF THE RECORD-BREAKER

10
Real Trained Wild Wolves

QUEEN
OF THE
HIGHWAY

5
Superb Acting Horses

Duke, the Famous Bandit Dog. The Overland Stage Coach.

WEEK OF OCTOBER 16

Broadhurst & Currie's Big Musical Comedy Success,
Nat M. Wills In "A Son of Rest"

dressing room, where she was making a genuine fight for her life. Moko had run all over the rear of the stage seeking a dark corner, when he spied the door of Miss Severson's dressing room slightly ajar and rushed in. The sudden entry into the glare from the incandescents threw him into a panic rage, and he jumped at her throat. She fought him off as best she could, but was unable to prevent his sinking his teeth into her left arm. She was afraid to make any outcry for fear of disturbing the show, and battled silently with the ravenous beast.

In the meantime, Lee Hertenstein, the animal trainer, rushed in with Duke, the big Great Dane who takes an important part in the show. Duke attacked Moko, more as a result of a long standing feud between the two animals than anything else, and Hertenstein grabbed both by the necks to separate them. Both Hertenstein and Duke were bitten by Moko, and it took several minutes before Moko could be dragged back into his cage.

A physician was summoned hastily from the audience, who cauterized and bandaged the wounds of Miss Severson and Hertenstein. Miss Severson went on with her [act and] finished the show, which had [been interrupted] only a few moments, [although she] was almost in a fainting condition from pain.

The room in which the fight took place was almost a total wreck. Everything breakable was thrown down and broken during the struggle, and everything torn that could be torn.

Miss Severson stated last night that she believes that Duke saved her life, and that he is going to have the finest silver collar that any dog ever wore.

Two days later, the Tribune *reported that Duke was indeed wearing "a fine new silver collar," given to him by the company in recognition of his backstage heroics.*

U "GIRLS" CRUSH
PLUCKY SOUTH HIGH 72–2

JANUARY 21, 1906 *MINNEAPOLIS TRIBUNE*

The University of Minnesota's 1971–72 women's basketball team, coached by Joan Stevenson, won five games and lost three. It is generally recognized as the school's first women's varsity basketball team. But women have represented the university on the basketball court since the late 1890s, not long after Dr. James Naismith invented the sport. Members of the 1904–05 squad, coached by Hugh Leach, were the first women to earn letters at the university. But with small colleges and high schools filling the schedule, the competition was not always fierce.

VICTORY COMES EASY
VARSITY GIRLS WIN FROM THE SOUTH HIGH, 72 TO 2.
HIGH SCHOOL MISSES ARE OUTCLASSED, BUT THEY PUT UP PLUCKY FIGHT
TO THE LAST—VICTORS' TEAM WORK IS SUPERB

The girls of the Minnesota basketball team ran up the highest score in the history of the team when they smothered the girls from South Side high last evening by a score of 72 to 2.

It was the fastest, snappiest and most brilliant play ever put up by the university girls and although the high school girls fought gamely to the last, they were badly outclassed and were never dangerous. Minnesota scored within a minute after the game started and continued to put the ball in the basket on an average of one a minute for the thirty-five minutes of play.

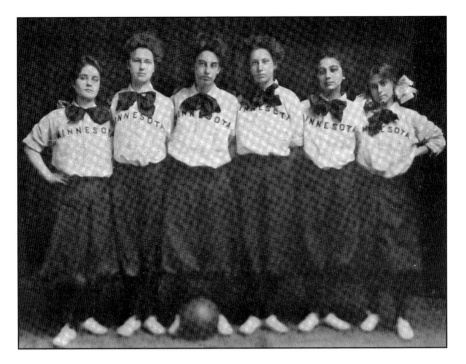

The 1907 University of Minnesota women's basketball team is said to have tried to boost attendance by offering informal dances after each game. *University of Minnesota.*

The superb team work of the Gopher girls was what won them the game by such a large score. South Side could do nothing to break up the perfect combinations and team play. The varsity played together all the time and with such speed and dash that the younger players were swept off their feet.

South Side's one score came near the end of the second half, when Miss Loeberg shot a basket for her team. The South Siders had worked the ball down the field on a spurt and it went out of bounds under the basket. A quick pass put it in position for a goal and the only score was recorded for the visiting team.

The game was remarkably free from rough play and the officials did not penalize a single player during the game.

Minnesota alumnae players who watched the game are united in saying that the Gophers this year have the fastest team in the history of the university. For so early in the year, the team play is remarkable and the speed is greater than ever before.

Hattie Van Bergen and Helen Cummings played the forwards in fine style, the former leading the team in basket shooting and getting into the

A basketball match drew a small crowd at Camden Park in north Minneapolis in 1910.
Hennepin County Library Special Collections.

team play phenomenally. Florence Schuyler was a remarkably steady center and Captain Dunn at guard was strong, coming up with the play and helping in running up the big score. Both Iris Newkirk and Clare Brown, who alternated at the other guard, played steady games.

For South high, Miss Loeberg and Miss Larsen played steady games and the others deserve mention for their plucky work.

There was a good attendance of university and high school students at the game, which was the first of the varsity schedule. Informal dancing followed the game, an orchestra furnishing music for a program of fifteen numbers. The teams lined up as follows:

Minnesota.
Cummings, left forward
Van Bergen, right forward
Schuyler, center
Dunn, left guard
Newkirk, Brown, right guard

South Side.
Mars, left forward
Loeberg, right forward
Larson, center

Law, left guard
Tenning, right guard

Goals, Van Bergen 10, Dunn 9, Cummings 7, Schuyler 6, Brown 3, Loeberg 1. Time of halves, twenty minutes and fifteen minutes. Referee, McRae; umpire, Weisel.

CITY'S BRAVEST WOMAN OUTWITS ROBBER, WOLVES, DUCKS

AUGUST 22, 1909 *MINNEAPOLIS TRIBUNE*

In May 1897, a highwayman accosted a Minneapolis boardinghouse matron named Eunice Albertson near Cedar Lake. According to brief reports in the Minneapolis Tribune *and* St. Paul Globe, *she was held by the throat, threatened with a rubber hose and robbed of one dollar.*

Twelve years later, Mrs. Albertson reappeared in the Tribune, *this time as a heroine, not a victim. Her new version of the Cedar Lake assault is rich in detail: A handkerchief covered the attacker's face. He used a sandbag to knock her flat. She fought back fiercely, knocked him to the ground, tore open his shirt, pulled down his kerchief and scratched his face. In the end he fled, leaving her bruised and bleeding in the woods. But she had held tight to her pocketbook, which contained $500.*

It's unclear how that $500 might have been overlooked in the original accounts. Whether or not the amount was inflated over the years, it definitely makes for a much better story. Is it any wonder that prairie wolves would be no match for such a woman?

George Walters was bound over to the grand jury yesterday morning in $750 bail to answer the charge of holding up Mrs. Eunice D. Albertson last Saturday near Cedar lake. The complainant bears the marks upon her face of the assault. It is stated that the region where the hold-up took place is infested with tramps, and the police will make an effort to clean it out.—*St. Paul Globe*, May 4, 1897.

City's Bravest Woman Adds to Her Conquests
Miss Eunice Albertson Routs Hungry Wolves with Dishpan.
Years Ago She Battled Highwayman and Saved $500.

The most courageous woman in Minneapolis is Miss Eunice Albertson. Fighting a highway robber with her hands and saving $500, fighting wolves alone at night in a prairie shack with a dishpan, hunting wild ducks with stones, are some of the adventures to her credit. During her 58 years she probably has experienced as much excitement and has done as many heroic deeds as will ever again come to the lot of a woman in this no longer wild and woolly West.

Newspaper readers will recall the robbery incident of about 10 years ago, when a burly highwayman's attempt to sandbag and rob a woman of $500 in the woods near Cedar lake turned out to be a complete fiasco because of the woman's coolness and bravery.

Miss Albertson was then, as she is now, housekeeper in one of the large woman's boarding homes of this city. She was walking through the woods along the north shore of the lake when the bandit slipped up behind her,

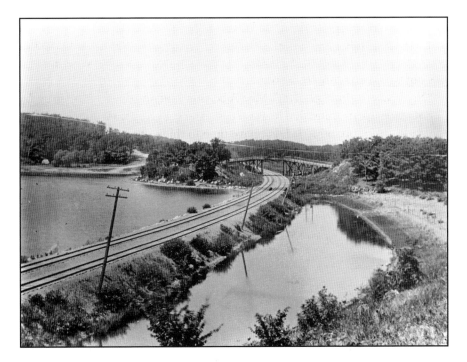

The north side of Cedar Lake, looking west, in 1898. *Hennepin County Library Special Collections.*

thrust his face over her shoulder with the command: "Hand over that money!" The woman had the $500, with which she was going to pay some bills, in a pocketbook held by her left hand. On her right arm she carried a large market basket. She faced about and saw that the robber had a handkerchief tied over his face under his eyes.

"Take that handkerchief off your face, if you're going to talk like that," she demanded without flinching.

"Quick, your money or your life," the man commanded, looking about him furtively.

"My life then, you big coward, to come at a defenseless woman in that way; aren't you ashamed—"

HIT WITH SANDBAG.

But just then a sandbag came out from behind the man, and the daring housekeeper dropped her basket, clung to her pocketbook, and with the other hand strove to ward off the blow aimed at her. She was not successful and was laid out on the ground by a sodden blow on the side of the neck. She rose in a moment, however, and dove at the man with her bare hands. She pulled open his shirt, scratched his face, struck him over the eyes with her open palms, and, seeing a swamp a few feet away, pushed him back into it.

The battle ended by the robber turning in flight, but not before his victim was bruised and bleeding about the face and her nerves so shattered that she has not yet thoroughly recovered.

"No, I wasn't afraid of him," Miss Albertson said, in telling of the struggle, "I just made up my mind that he wasn't going to get my money, and he didn't," she added triumphantly. "I didn't have time to think of screaming. It took all my attention to think of pushing him back into that swamp and dragging the covering off his face. I guess that scared him and made him make off."

The robber is still in the "pen" and the woman has made a great deal more extraordinary history.

One evening, about three years ago, a group of girls at the boarding house dared Miss Albertson to hold down a claim in North Dakota. She accepted the dare, and for the last three years she has been living absolutely alone in an 8 by 10 shack on the open prairie near the Lone Trail reservation, 12 miles north of Williston. The land she homesteaded has cost her in all $1,000. She returned this spring possessed of property worth over $8,000.

The Sioux Indians called her "Wauneta," which means "The Lonely One." There were absolutely no trees in sight and all the water she used had to be carried one mile. Her nearest white neighbor was four miles distant.

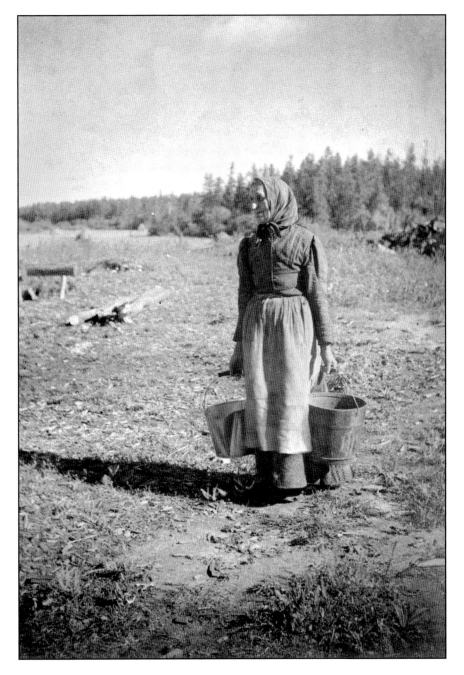

I can find no photo of the remarkable Eunice Albertson. You'll have to settle for this haunting image of an anonymous woman carrying pails across a desolate stretch of the northern prairie in about 1900. *Minnesota Historical Society.*

"Those were great days," she always begins when asked to tell of her adventures. "It grew mighty lonely at times, and I wished I could run away from the deadly monotony and silence of the country. But once in a while something would happen to furnish excitement enough to last for a long time."

"What is the most exciting adventure you ever had?" she was asked.

"I suppose the time I fought the timber wolves with a dishpan kept me wider awake than anything else I ever did up there. It was in the dead of winter, and I had not seen a soul in two months. The snow was piled up over the fences and drifted up as high as the top of my little shack. I went to bed early in order to sleep through the long winter night after bringing in enough wood to keep me warm for at least 48 hours if I should be snowed in. The coyotes began to howl at nightfall, as usual, but I was quite used to them. They never came near the shack. I soon fell asleep.

"But later in the night I was awakened suddenly by a new, wilder blood-curdling note that was a cross between a howl and a scream. The scream part of the howl spelled hunger, the raw, ravenous hunger of the long winter when the deep snow covers up nearly everything alive. The noise came nearer and nearer until they were on the other side of the door. I jumped out of bed, threw on a wrapper, and lifting the latch of the door a few inches, looked out. My heart rose into my mouth at the sight of two huge gray wolves almost on my threshold, their long noses pointed to the sky, their mouths wide open, and slender, dripping tongues hanging over their white fangs.

ATTACK MADE ON DOOR.

"I slammed the door shut and dropped the latch. But my fear did not diminish for I knew that my door was very thin and that the latch could be broken off with a little pressure from without. I threw more wood on the fire and examined the rifle I kept standing in the corner. I had never before found any use for the gun, and to my consternation I found that I had forgotten how the thing worked, and that I could not get the hammer set just right.

"By this time the wolves were leaping up on the door and the latch was creaking. I crouched back in one corner and, for once in my life, I was thoroughly frightened. I saw the screws in the latch giving and working loose. There was no way to brace the door from the inside. There I was with a no-account gun in my hands.

"I saw the latch was about to come off, and in one last mad endeavor to protect myself, I rushed for my bed. I do not know whether I intended to get in it or to wrap myself in the thick clothes; but in my haste I knocked my large dish pan off its nail and it fell banging to the floor. This gave me a

brilliant inspiration. I grabbed it, reached for a large iron spoon and raised my hand to beat the pan just as the door fell in and the wolves dropped nearly into the middle of the little shack.

"Then how I did beat that old pan! The big brutes fell over each other to get through the door again. I ran to the opening and beat harder than ever, and those animals scooted off over the drifts like a pair of fleeing ghosts."

"But were there no pleasures to the country at all?" one of her audience asked her, after they had discussed this thrilling escape.

"O, yes, I had plenty of fun at times. I used to go hunting quite often. No, I never used a gun. I never learned to use the rifle very well, and generally left it at home. I just used stones. I killed wild ducks along a nearby creek in the fall, when they would stop to feed by the thousands, by throwing rocks at them, and I ate them until I grew tired of their flesh."

Her listeners grew incredulous at this announcement, and she answered the questioning eyes thus:

"It wasn't such a feat as you might imagine. I could creep up quite close before the birds would hear me. And then I used to practice throwing a good deal when I walked alone across the open prairie. There was nothing else to do most of the time, and I finally became quite expert in throwing stones."

"What other good times did you have?" we asked.

"Well, the last summer I was there the young people about that section of the country got acquainted with me, and every Sunday, they used to drive over the prairie for any number of miles and have dinner with me. We used to have some good times. Most of the people nowadays in that country, you know, are men, young men. Girls are rather hard to find. But somehow the young fellows used to come up every Sunday with a girl apiece, and very often with a pair of chickens or a bushel of apples, too. I had only two chairs, and knives and forks for about two persons, and we ran short of dishes of all kinds on every occasion. But that never bothered us. The young people seemed to like to share a cracker box with each other, and when the gravy was poured over their crisp, brown, fried chicken from a sizzling frying pan instead of from a Haviland gravy boat, they never seemed to mind it. Then there were riding and running contests in the afternoon and sometimes one of them would bring a fiddle. Yes, we often went to Williston to attend a little wedding; but the bride and groom, both hard-working young people, were generally with us at the very next meeting and took no offense at the fun we had over their blushes and shyness."

The last incident Miss Albertson recited (she could tell no more after once recalling the experience) was the tragic story that this "unpainted wilderness," as it is called, has often given the world.

It happened in the terrible winter of 1907, the coldest the Northwest had seen for 20 years. The thermometer had dropped to 60 degrees below zero. The windows in the shack had frozen closed over night so tightly that she had to pry them open with knives heated in the stove. Thirty feet of snow had drifted into the hollows and coulees, and there was little to do but to pile wood on the fire and listen to the bitter wind shriek over the glistening sea of snow. It was on one of these cold days that a Scandinavian neighbor made his way to her house on skis. When she had helped him thaw out his nose he told his sad story.

Two miles distant from his place a young school teacher was trying to live through her first winter on the prairie. Her neighbors had visited her and warned her that she had not laid up enough fuel and provisions to last her, but she would not heed them and spoke harshly to them about meddling with her. They left her alone.

The visitor could see her shack from the top of the hill where he lived and watched daily for the thin thread of smoke to disappear. That very day it had faded away and the little wooden shelter stood out stark and solitary on the cold, pitiless world of snow.

He hastened over to the shack on his skis, broke in the door, and found the young teacher lying dead and frozen on the floor, wrapped in all the bedclothes in the hut. All her furniture had been burned and a box of candles had been half eaten. Miss Albertson made her way over the crust of snow on skis and helped give the girl a temporary burial in the deep snow.

Miss Albertson is still a vigorous, well-preserved woman and looks as though she might easily take care of herself through any more adventures or hardships she might care to negotiate. Though her hair is white and lines furrow her face, yet the blood of youth still tinges her cheeks and her bright, brown eyes sparkle with fire. She will always look the part she has played as a woman to whom the heroic is taken as a matter of course.

FOOTBALL COACH HAS SURGEON'S TOUCH

JANUARY 26, 1910 *MINNEAPOLIS MORNING TRIBUNE*

Dr. Henry L. Williams coached the University of Minnesota football team from 1900 to 1921. He directed the boys to 136 victories, which remains the school record. Back then, coaches had to do more than diagram plays, recruit prep stars, give pep talks and talk to Sid Hartman. Dr. Williams frequently tended to his players' injuries and, in at least one case, performed surgery on one of his top student-athletes.

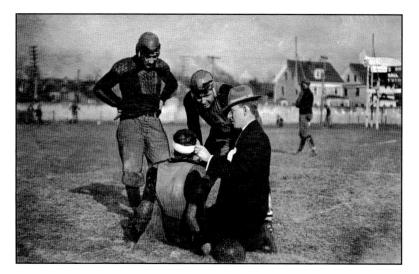

Coach Henry L. Williams tends to a Minnesota player injured in a 1907 game against Nebraska at Northrop Field in Minneapolis. The Gophers won 8–5. *Minnesota Historical Society.*

John M'Govern Under Knife
Minnesota Quarterback Operated on Appendicitis.

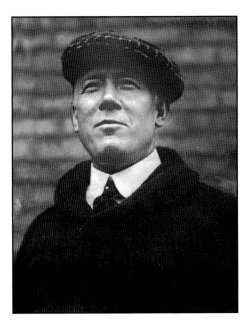

Dr. Henry L. Williams. *University of Minnesota.*

Johnny McGovern, the University of Minnesota football star and all-American quarterback, is eligible to membership in the "Appendicitis club" recently organized in Minneapolis. The little quarterback was taken ill Saturday night and when it was found that he was suffering with appendicitis and that an immediate operation was thought to be imperative, he was taken to St. Barnabas hospital where the operation was performed Monday night. The operation was performed by Dr. H.L. Williams, the Minnesota football coach. Last night the patient was reported to be resting easily and a speedy recovery is expected.

CHILDREN ENLISTED IN WAR ON FLIES

AUGUST 21, 1911 *MINNEAPOLIS MORNING TRIBUNE*

From Worcester, Massachusetts, to Redlands, California, cities across the country declared war on disease-carrying houseflies in 1911. Children competing for cash prizes killed flies by the millions that summer. One Georgia boy alone turned in 2,199,200 dead flies to win the top prize of ten dollars in Savannah's "Swat the Fly" contest.

"All the intense activity directed toward the destruction of the musca domestica," the Jefferson Jimplecute *declared with bemusement, "is the discovery that the fly—the common house fly, once treated almost as a pet—is one of the most deadly of all menaces to the human race."*

The Texas newspaper was not alone in poking fun at the public health initiative, but for kids it was a chance to stave off summer boredom, kill helpless creatures and compete for cash. In Minneapolis, the top prize was a nothing-to-swat-at fifty dollars. The Morning Tribune, *which sponsored the two-week contest, put up the money, laid out the rules and offered fly-killing tips.*

The rules:

"Entrants must be children under 16 years of age. Flies caught in any manner except by the use of sticky fly paper will be taken in the contest. Flies may be swatted, caught in traps, poisoned, exterminated by drowning, the use of sulphur fumes or other means.

"Boxes, made especially for the Tribune Campaign *contest and given free by the Standard Paper box company of 501 Third street south, in which all flies are to be sent to the health department to be counted, will be given all entrants.*

"The name and address of the contestant must appear on the box. The box must be tied securely. All flies delivered for the contest must have been killed by the persons to whom they are credited."

What a disgusting task, you might be thinking, counting all those fly carcasses. The task was indeed disgusting, I'm sure, but the flies were not counted one by one. Flies turned in around the country, and presumably in Minneapolis, were measured by volume. The calculation: 1,600 flies to the gill, or a quarter pint. Happily, no recounts appear to have been demanded.

CITY FLYLESS CRUSADE STARTS THIS MORNING
MINNEAPOLIS CHILDREN READY FOR CAMPAIGN AGAINST DISEASE CARRIERS.
SUB-STATIONS OPEN AT 10 O'CLOCK TO RECEIVE DEAD PESTS.
BOYS AND GIRLS DEVISE MANY SCHEMES FOR TRAPPING VICTIMS.

Ten little flies all in a line;
One got a swat! Then there were

Nine little flies, grimly sedate,
Licking their chops—Swat! There were

Eight little flies raising some more—
Swat! Swat! Swat! Swat! Then there were

Four little flies, colored green-blue;
Swat! (Ain't it easy!) Then there were

Two little flies dodged the civilian—
Early next day there were a million!

The great battle against the fly starts today.

The opening gun of the war against the disease-carriers will be fired at 10 o'clock when sub-stations in the 13 wards of the city will open to distribute supplies for the youthful soldiers who are marching against the hosts of Mr. Fly.

Flies spent their last peaceful day in Minneapolis Sunday. Without a thought of the war that opens today they hummed and buzzed in cafés, restaurants and houses. But it was the ball before Waterloo. They danced while Young America of Minneapolis was busy putting the finishing touches to fly traps and swatters. While the youth of the city were burnishing their arms, making last preparations for the march against the foe today, the fly hummed as merrily as ever.

Two weeks from today the enemy will have been exterminated. The campaign is starting with a rush this morning with the members of the troops of

the Boy Scouts and the members of the Boys' club leading the fight. Thousands of Minneapolis children thronged the sub-stations yesterday attempting to secure supplies for their fight against the fly but all were refused.

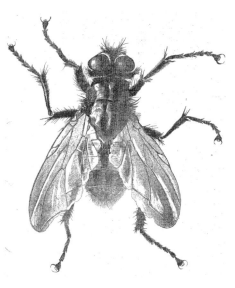

Public Enemy No. 1: The common housefly. Star Tribune *microfilm.*

SUPPLIES AT SUB-STATIONS.

At 10 o'clock this morning every child in the city who wishes to enter the contest should visit the sub-station in the ward in which he lives. There cardboard boxes made for the contest by the Standard Paper Box company, 501 Third street south, and given free to the children will be distributed by [the city's] Department of Health…Yesterday several clerks and employes of the department went over the card index system putting the cards in their place and arranging for a gigantic tabulation system by which the results of each day's battle against the fly can be kept.

Daily records of the day's death toll will be kept. Each child's name will be put on a card as soon as a box of dead flies has been received at the department, bearing the name and address of the killer. The number of flies contained in the box will be entered on the card and as each day passes additional figures of the flies killed by that contestant will be added to the card. Totals of the entire number killed will be recorded each night and The Tribune will every day print the standing of the leaders in the contest. The names of all the contestants and their standing at the close will be printed in the Sunday Tribune of Sept. 3.

TAKE FLIES TO STATIONS.

The sub-stations will give out supplies until 11 o'clock this morning, opening at 10, and will be open again in the afternoon between 3 and 4 o'clock. Dead flies must be taken to the sub-stations before 1 o'clock in the afternoon. No flies will be received after that time. Wagons from The Tribune will make a trip around the city every afternoon, visiting each sub-station, collecting the dead flies and

leaving new supplies. The first trip will be made this afternoon. If you have any dead flies be sure and get them to the sub-station before 1 o'clock this afternoon.

Many are the schemes several small boys near Lake Harriet are resorting to secure fly traps and places to set them. One lad Saturday called on four grocers in the Linden Hills District and asked where they kept their flies.

"We have no flies—what do you want with them, anyway?" asked one grocer of him.

"I want to catch your flies for you. Where do they congregate the thickest?" the boy asked. The grocer showed him. At the back door of the store thousand of the disease carriers were feasting on the remains of a crushed watermelon.

The boy eyed them. Then he made the grocer this proposition:

"If you'll give me 50 cents I'll catch all those flies for you, keep them away from you for two weeks and by the end of that time if there are still any flies around the door in any number I'll keep them away for two weeks longer for nothing," he told the grocer.

"Do you mean to tell me you'll stand here at this door every day for two weeks and brush away flies for the small sum of 50 cents?" asked the grocer, taken aback by the offer.

"No, I didn't say that," returned the boy. "I said I'd catch the flies and keep them away; not that I'd stand here all that time. That has nothing to do with my keeping them away. I'll buy two traps with the 50 cents, put them here at this door with some bread and milk bait in them and before half a day has passed I'll have the traps filled twice. That will take away a larger number and I'll fill the traps every half day from then on for the rest of the two weeks. I will send the flies to The Tribune sub-station, get the $50 prize and you'll be rid of your flies, and I'll have enough money to last me all winter at school. Will you do it?"

"Guess I will," the grocer said. The bargain was made and the traps will be set this morning.

East Side Boy's Scheme.

Over on the East side another boy went to the owner of a livery stable and asked permission to put some traps on the manure box at the end of the stable. The proprietor, bewildered, asked what kind of traps.

"Fly traps, of course," said the boy.

"Well, why do you want to catch flies for me?" asked the liveryman.

"It's not for you," replied the boy. "It's for The Tribune contest, and because flies are disease spreaders and germ carriers that we want 'em.

There are enough flies at the rear of this livery barn to win a contest if I could get them all by myself, but there will be so many kids here to see you and want to catch your flies that I'll have a hard time getting very many after the contest starts Monday."

The liveryman helped the boy make a trap. The trap was made out of a half barrel. They adopted the principle of the little wire screen cage trap, which has an inverted conical inlet for the flies extending upward from the base, where a bait of sweetened water or bread and milk is put to draw the flies. Applying this principle, they took a common sugar barrel, replaced the top with a cover of wire screen, sawed a hole 12 inches in diameter in the center of the bottom and into this inserted a cone made of wire screen, having a diameter at the base equal to the hole in the barrel and an aperture at the smaller end about three-quarters of an inch across. When thus fixed and made fly tight, except for the inlet, the barrel was placed on supports which raised it from the ground a few inches so that the bait could be placed beneath to draw the first flies. When a good number of flies have been trapped the very buzzing will attract other flies from all directions.

FOLLOW-UP: Updated standings were published daily in the Tribune. *The competition for the top three spots was especially fierce and full of intrigue, with the eventual winner holding back thousands of flies until the final day. When the carnage, er, contest ended on September 2, more than three million flies had been killed. The death toll was less than that of contests in eastern cities, according to health officials, because of a superior garbage-collection system. Minneapolis required that garbage be wrapped in paper before being placed in cans, eliminating a major breeding ground. In its final report, the* Tribune, *perhaps caught up in the excitement, declared Minneapolis to be "practically flyless."*

The top prize winners, along with the number of flies killed:
First prize, $50: George Knaeble, thirteen, 515 Plymouth Avenue, 266,340.
Second prize, $25: Theodore Bedor, twelve, 4114 Blaisdell Avenue, 264,660.
Third prize, $15: Henrietta Beck, ten, 2218 Aldrich Avenue North, 189,480.
Fourth prize, $10: Edward Hirt, eleven, 1909 Fourth Street North, 154,340.

CANOEING WITH THE OJIBWE

SEPTEMBER 3, 1911 *MINNEAPOLIS TRIBUNE*

Have you read "Canoeing with the Cree," Eric Sevareid's engaging account of his 1930 canoe trip from Minneapolis to Hudson Bay? Sevareid, seventeen, and a nineteen-year-old friend paddled more than 2,200 miles that summer. They caught fish, shot rapids and ate pemmican. They mingled with Indians and slept under the stars.

A few decades earlier, another seventeen-year-old boy from Minneapolis set out on a canoe adventure that was nearly as ambitious and just as likely to inspire others to pack up a canoe and head north. Bruce Steelman submitted this account to his hometown paper:

MINNEAPOLIS CANOEISTS TOUR UPPER MINNESOTA
THREE BOYS COVER 1,100 MILES ON LAKES AND RIVERS IN FIVE-WEEK TRIP.
RANGE WATERS AND RAINY RIVER COUNTRY EXPLORED—RARE EXPERIENCES.
THEY COME DOWN MISSISSIPPI FROM BEMIDJI—OUTING TO BE REPEATED.

Bruce C. Steelman, 119 Thirty-third street west, his brother, Clyde, and Loyd Sherman have returned to Minneapolis after a canoe trip of 1,100 miles on the lakes and rivers of northern Minnesota. Some of the places visited have seldom been visited by white men. The boys plan to repeat the trip some time.

Bruce Steelman tells the story of the voyage as follows:

"Loyd Sherman, my brother, Clyde, and myself had long planned to take a canoe trip. We shipped out two canoes and supplies to Tower, Minn., on July 16. We stocked up with bacon, salt pork, navy beans, flour, corn meal, rice and everything that generally goes with a camping outfit. We started from Minneapolis, where we all live.

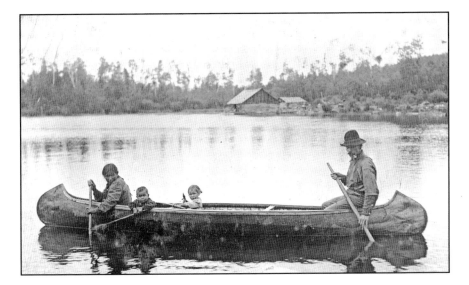

An Ojibwe family paddled Lake Vermilion, the starting point of Bruce Steelman's 1,100-mile journey, in about 1905. *Minnesota Historical Society.*

"We arrived at Tower at 11 a.m. the next day. Early in the afternoon we launched our canoes and pushed out from shore in [Vermilion] lake. Crossing the lake we entered the river of the same name and passed through Crane lake, Sand Point lake, Namekan lake and some smaller bodies.

TEPEE PITCHED.
"At the outlet of the [Vermilion] river we pitched our tepee. The owner of Hunters' lodge there advised us to ship one of our canoes back, because there were many portages to make, but we went on with the two canoes.

"The first day out from there we made five portages. One of the canoes got away from us and was swept down the rapids. It turned partly over and filled with water. We lost all our ammunition, part of our clothing and some of our grub. Loyd ran down stream and headed off the canoe, jumped into the stream and towed it to shore. Our camera was soaked and this prevented us from taking many pictures along our trip as we had intended doing.

"At this point we decided that one canoe was plenty and were sorry we had not followed the advice of the man at Hunters' lodge. The next morning Loyd and I started back with the smaller canoe to the foot of [Vermilion] lake and shipped it back home.

"My brother was to go down stream a little farther with the large canoe and the supplies to a small creek. Though we had never been there we

thought we could easily find him. After getting the canoe off our hands we started back overland to join Clyde. We found the creek, but Clyde was not there. As we had spoken of no other meeting place we did not know what to do. We made a search of the surroundings and found an old boat, which we got into and went back to our camping place of the night before. He was not there. Night was coming on and we had nothing to eat with us and no gun. In the meantime a strong wind came up and a heavy shower, which drenched us to the skin in a few moments.

HAD NO DRY MATCHES.

"We had no matches that were dry and we could not start a fire. It was now dark. We groped around and found a windfall, pulled off some boughs, made a bed and remained there all night. At the break of day we got out and started back in the boat. The morning was bright and the warm sun felt good to us. We had not gone far when we saw three moose only a few yards away. They trotted off briskly.

"After a search of a couple of hours we found Clyde and the supplies. We were more anxious to find the latter than the former, for our appetites were pretty keen. The waves had driven Clyde ashore and we had passed him.

"In a few days we had reached the Rainy Lake river, after making about 18 portages, two of which were over a mile long.

"Up to this time we had caught wall-eyed pike weighing up to seven pounds and plenty of northern pike. We had also seen a number of deer.

"At our first camping place on the Rainy Lake river we were besieged with timber wolves. We kept up a pretty high camp fire and they kept their distance, but hung around most of the night. When daylight came they had disappeared and we saw nothing more of them.

"We saw many Indians along our trip, but as they could not talk English they could not benefit us much. They have some fine birch bark canoes which we could have bought for from $3 to $10.

"We started up the Rainy lakes and could not make over about seven miles a day, as it was showery for about three weeks. We had to use our compasses, for we could not tell the islands from the mainland. Part of the time we camped on the Canadian side. Some nights we camped on islands when we thought we were on the mainland. Moose seemed plentiful on the international boundary. Fishing was most excellent.

"The trip through the lakes was very interesting as the shores are very rocky and covered with timber. There are scarcely any white men up there, but Indians are everywhere to be found. We traveled by moonlight a great

deal, for the nights were calm while the waves rolled nearly every day. We lost our way many times on these lakes and were several days reaching International Falls, where we camped for a few days.

"We shipped our canoe and luggage to Bemidji, Minn. Here we launched our canoe in Bemidji lake, the outlet of which flows into Cass lake, and after passing this lake we went down the river to Lake Winnibigoshish. The Mississippi is so shallow up there that we were aground every little while and we had to work like galley slaves to get along.

"From Bemidji to Minneapolis by the river it is over 500 miles. We found but few whites along the river clear down to Aitkin.

"We were almost out of supplies and could get but little from the Indians. When we were almost ready to land at home we came very near losing our whole outfit in a log jam. We landed Friday evening at the Union station, Minneapolis, at 7 o'clock. All we had left of our provisions was salt and pepper and a little rice.

"The trip cost us about $40 apiece, not counting our experience."

SPEED KING DEFIES DEATH
AT FAIRGROUNDS

JULY 19, 1914 *MINNEAPOLIS TRIBUNE*

Renowned as "the world's greatest aviator" in the early twentieth century, Lincoln Beachey was a barnstorming stunt pilot who invented many of the daring maneuvers performed at aerial shows today. His feats were seen by millions of people from San Francisco (where he "bombed" a fake battleship) to the White House (which he dive-bombed in another mock attack). More than 200,000 people are said to have witnessed his final flight at the Panama-Pacific International Exposition in March 1915. The strain of a new maneuver tore the wings off his monoplane, and the fuselage plunged into San Francisco Bay. Strapped into the cockpit, he drowned before rescuers were able to reach the wreckage.

Beachey performed at least four times in the Twin Cities. Here's an account of his show at the state fairgrounds in July 1914, eight months before his death:

TWENTY THOUSAND SEE BEACHEY AND POPULAR OLDFIELD
BIRDMAN SHARES THE HONORS WITH THE PERENNIAL FAVORITE.
ALL SORTS OF AERIAL CAPERS CUT BY THE WORLD'S GREATEST.
MAMMOTH CROWD WATCHES THE FUN AND APPEARS TO LIKE IT.

BY JOE MCDERMOTT.

Minneapolis saw Lincoln Beachey take liberties with the law of gravitation and get away with it yesterday at the State Fair grounds.

Twenty thousand were there and every one of the twenty thousand cheered him, perhaps, as no individual has ever before been cheered at

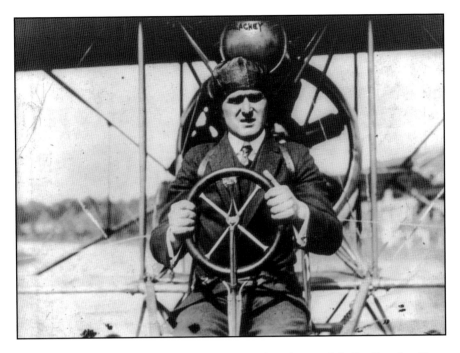

Lincoln Beachey in May 1914, a year before he died in a plane crash in San Francisco Bay. *Library of Congress.*

the midway enclosure. He looped the loop, he skimmed and skidded, flew upside down and inside out, shut off his engine and dropped like a plummet until folks shut their eyes and feared that the daddy of all the birdmen had finally met his doom. But he didn't even skin his knuckles and it would seem that the grim old guy with the long galways and the keen scythe will have his hands full catching up to this young bird.

Old man gravitation, for these thousands of years a sworn foe of the human race, was kicked in the seat of the pants yesterday as he has not been kicked in many a day.

BARNEY WAS THERE, TOO.
But Beachey wasn't all the 20,000 paid their good dough to see. Marching shoulder to shoulder with the aviator in the estimation of the crowd was Barney Oldfield. He was the same old Barney, with the same old cigar and the same old smile and he was just as popular with the crowd as he ever was. A little heavier and a trifle grayer about the temples than on his first visit to the Twin Cities back in the dawn of the auto racing game, he was cheered just as hard and just as often as in the past. Some may call Beachey the headliner of the combination,

but from the volume and density of the applause it is safe to go on record that Barney was the co-star, at least, yesterday.

The crowd was far larger than anyone expected and that includes Old Bill Pickens, who has been associated with Oldfield before Henry Ford broke into the league. Pickens, the original optimist, figured on a 12,000 crowd. As a result of the conjecture only that number of tickets were taken to the grounds. A long time before the fun was billed to start the management discovered the mistake. Hundreds of automobiles and thousands of pedestrians began their assault on the gates in earnest about 2:30. Ticket sellers, ticket-takers and guards were overwhelmed by the avalanche and the gates were clogged with perspiring humanity before the management knew what was happening. The clamoring mob at the gates looked as big as ever when it was discovered that every ticket on the grounds had been snapped up by the ravenous speed fans. A limited supply of old State Fair tickets were commandeered and these took care of a section of the crowd.

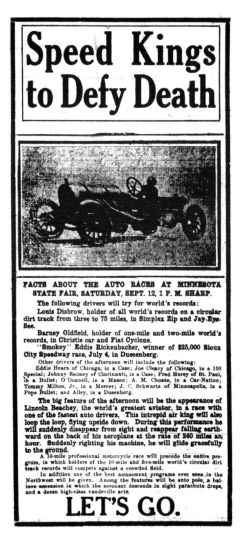

A *Minneapolis Tribune* ad touted Beachey's return to Minnesota for another performance at the fairgrounds in September 1914. Star Tribune *microfilm*.

Others unable to secure tickets hurled pieces of silver at the attendants and tramped their triumphant way in over the scrambling ticket choppers. The Beachey-Oldfield combination departed last night with a fair-sized grip full of currency, but it's safe to say that a few of the boys on the gates fared almost as well, relatively speaking.

Came on a Special.

Beachey arrived shortly before noon on a special train from Winnipeg and he did not have his machine assembled and ready for aerial climbing until after the scheduled starting time. Barney Oldfield was the first on the program and he received a typical Oldfieldian ovation when he swirled onto the track in his Fiat Cyclone. His first venture was an attack on the Hamline track record, a mark established by himself. The track was heavy with the summer's dust and a bit treacherous on the turns, but Barney said he thought he could knock the bottom out of his old .49½ performance. He failed but he did skim the mile in an even 50 seconds. That didn't lower Barney's whit in the estimation of the crowd and all hands cheered him and his cigar just as hard as though they had done the four-quarters in nothing flat.

With Barney out of the way, Beachey was announced and the crowd loosened up its wilted collar and prepared for a careful survey of the upper regions. Then the famous machine was wheeled out by a bevy of young men eager to touch the hem of the Beachey garment. Following was the sunburned little rough rider of the sky who has flown around the capitol at Washington; under the suspension bridge at Niagara Falls, who won the New York to Philadelphia air race, who has been farther above the earth than any living American and who has done things in the sky that make most people dizzy to think about. The hero-worshippers in the pilot's wake started the Gnome motor buzzing near the pole in front of the grandstand and some half-hundred railbirds were chased off the fence by the breeze from the blades and the accompanying dust.

And Then He Started.

Then they cast off the gang plank or whatever they do aboard aeroplanes, the staccato sputter of the exhaust drowned out all other noises, the machine glided along a hundred yards and then soared with the grace of a swallow above the heads of the crowd.

After some straightaway flying to warm up his motor, Beachey opened up and in the argot of baseball, "he had everything." He cut some 90 degree banked figure eights, he dipped up and down with the ease of a bird, drove the machine with his hands above his head, tore off some aerial tangoing and then swooped down in front of the grandstand and made a precise landing at the finish line. The crowd, which had been held spellbound by his evolutions, broke into cheers. Beachey had been up only five minutes but it seemed fifty.

Then there was a burst of smoke, a roar, a zip and Oldfield swept past the grandstand in his 300 horsepower Christie. He was still on the trail of a new

track record, the announcer confided. But the engine was not working the way the driver desired and the best he could do was a mile .51.

DROPPED LIKE A ROCK.

Beachey took the stage again with Oldfield's disappearance. He started as though he meant to shatter a few altitude records. After fighting his way up to 3,000 feet, he shut his engine off without warning and began to drop like a rock. According to what we learned in physics, a body drops 15 feet the first second and the square of 16 times two, or some such matter, each succeeding second. It looked as though Beachey traveled all of that fast, but being uncertain as to the exact formula used in determining the velocity, no one in the press box was able to figure out his speed.

The veracious press agent says the speed of the falling plane is about 240 miles an hour, and for want of proof it may be better to let it go at that. In his descent, Beachey assumed control of the plane about a thousand feet from the earth and after flying upside down, volplaned to the track. More cheers.

The thread of thrills was then taken up by Beachey and Oldfield in their widely heralded race for the "championship of the universe." After a spectacular dash around the track, with Beachey a few feet above Oldfield's head like a giant dragon the majority of the distance. Oldfield was declared the winner in .50 2-5.

THEN THE BIG SHOW.

Then followed the big spectacle of the afternoon—Beachey looping the loop in midair. It was the first time in the history of the northwest that this has been done and the daring bit of aerial legerdemain came as a spectacular climax to the afternoon's work. He circled around several times before attempting his greatest bit of art. Then he made a sudden little dip, shot straight down, up, and clear around for a perfect loop. Three times he did it before alighting.

In his three appearances in the air, Beachey was off the ground for a total of only 17 minutes but it's a safe guess that the twenty-thousand saw more action crowded into those 17 minutes than ever before in their lives.

There are people in Minneapolis who say they were held up 25 cents apiece extra to get into the grandstand, in the face of advertisements to the contrary. There are others who say they were charged 25 cents for the privilege of parking their automobiles in the paddock. And there are still others who were caught in the rush for street cars after the show and were late to dinner. But nobody has come forward who wouldn't do the same thing or go through the same rush again, rather than miss the performance.

CHIMNEY CLIMBER LANDS IN HOSPITAL, WINS BET

July 21, 1914 *Minneapolis Tribune*

On a friendly wager, a Minneapolis man set a blistering pace in the vertical portion of an unusual duathlon: an eight-mile run followed by a seventy-five-foot chimney climb. Alcohol may have been involved at some point.

Chimney Climber Wins a Marathon-Like Race
Runs from St. Paul; Scales Chimney; Wins Bet; Faints
Albert Williams, Blistered by Hot Stack, Falls to Ground—
In Hospital

Albert Williams, 3805 Thirtieth avenue south, is just as good a long distance runner and high climber as he said he was. He proved it yesterday.

Williams and his friend, Lewis Otterman, Tenth avenue and Third street north, were discussing various feats of strength and endurance. Williams told him of some of the things he had done. Otterman was inclined to scoff.

"I'll tell you what I'll do," said Williams, "if you want to risk any money, I'll bet you $50 I can run from the St. Paul courthouse to the Milwaukee shops at Twenty-second street and Minnehaha avenue, climb that 75-foot smokestack there, walk twice around the top of it, and then come down."

He Takes the Bet.
"It can't be done," said Otterman, "but I'll take that fifty away from you. It will be easy money."

Williams went to St. Paul yesterday. With him he took a professional running suit.

He started from the courthouse with plenty of witnesses and he dog-trotted to Minneapolis with friends in an automobile seeing that he didn't do any backsliding.

He was pretty tired and hot when he got to the Milwaukee shops, but he shinnied right up that chimney. Near the top of the chimney it was tremendously hot, Williams found out. He walked around the top twice, but his legs and arms were badly blistered.

He got only about half-way down the chimney on the last and final feat when he fell, dazed by the heat. No bones were broken, shop employes and Williams' friends found, and he said himself he wasn't hurt.

COLLAPSED IN STATIONHOUSE.
To get his blistered legs and arms treated, he walked to Dr. J.K. Moen's office, 2620 East Lake street. His burns were attended, and then the doctor took him to the Sixth precinct police station. Williams collapsed there, and he was taken to the City hospital.

He is said to be suffering from shock and heat. But he collected the money.

LOCOMOTIVES COLLIDE AT THE FAIR

SEPTEMBER 5, 1920 *MINNEAPOLIS SUNDAY TRIBUNE*

The 1920 edition of the Great Minnesota Get-Together was a fair to remember. It featured ten tons of butter, eighty acres of farm machinery, "9-foot-5" Jan Van Albert, Ruth Law's Flying Circus and speeches by presidential candidates Warren G. Harding and James M. Cox. The main attraction on opening day was a "Gigantic Locomotive Collision" at the grandstand, with two 160,000-pound engines slamming into each other at sixty miles per hour. The collision was the top story on A1 the next morning in the Sunday Tribune. *The fair staged three more locomotive collisions, in 1921, 1933 and 1934.*

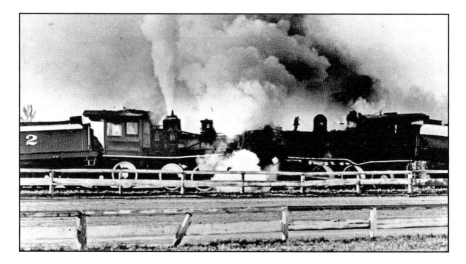

Two locomotives collided at the grandstand in 1934. Star Tribune *archives.*

55,117 Defy Rain for Fair's Opening
Locomotives Crash on Schedule Time
Crowd Waits Three Hours for Spectacle That Divides Honors with Wilson's Flying Stunts—Opening Day Is Record.

A great big good-natured crowd of 55,117 people, intent upon watching two engines meet at top speed for the first time in their experience, disregarded a steady drizzle descending unceasingly from an overcast sky yesterday, and gave emphatic impetus to hopes of State Fair officials to make this year's attendance break the world record set by the Minnesota State Fair last year.

The first day crowd in 1919 was only 30,631, little more than half yesterday's attendance, despite the unkind treatment of the weather man.

Crowd Out for Good Time.
The crowd was remarkably good-natured in the face of adversity. They were out for a good time, and were determined to have it, even if their best clothes did get soaked. For three hours in the afternoon, a solid mass of humanity sat in the sold-out grandstand, unprotected from the merciless drizzle.

Thrills a-plenty rewarded the afternoon crowd for its three hours' wait in the dripping grandstands, when Ruth Law's flying circus, featuring Al Wilson, and the engine collision, occurred exactly on schedule time late in the afternoon.

Collision Missed by None.
Visitors who had preferred inspection of the exhibits in Fair buildings to the full program of circus features and races offered on the grandstand track could not resist the chance to see the rail collision. Without question this unique feature was the crowd-pulling event of the day.

Steaming slowly up and down the brief stretch of track, the engines, piloted by W.D. Carrington and Harry Tatum of Inver Grove, made several preliminary test trips.

Then, with a shrill blast of their whistles, the engines concentrated the crowd's attention on the last trip they were to make. Carrington opened wide the throttle of engine "573," she started forward, almost immediately gaining her maximum speed.

He jumped quickly, but not quite quickly enough. Landing heavily in the adjacent mudbank, he turned three complete somersaults, and struck his ankle against a boulder, spraining it.

Tatum Swings to Safety.

Meanwhile, Tatum had started No. 478 more slowly. But as he saw the other engine tearing down the track, he threw the throttle wide, and swung to safety. The two engines, rushing inevitably toward each other, met almost squarely in the center of the track. There was a terrific explosion and "478" crashed clean through the front of "573," and halted dead.

Then the fun began. Determined to get a close view, grandstand, bleacher and Machinery Hill crowds decided at one and the same moment to reach the scene of the collision. Wire fences, wooden barriers, policemen with wildly waving arms were no barriers whatever. Within two minutes the racetrack, the central oval, and the fields beyond the engine track, were black with people. Up and [d]own the track and over the adjoining fields the people ranged, hunting bits of wreckage for souvenirs. Soon there was little left that was not too heavy to carry away.

Al Wilson's Feats Win Thrills.

The collision, although it was listed as the central attraction of the day, was not so successful in rousing thrills as the unparalleled feat of "Al" Wilson, the intrepid acrobat, with Ruth Law's flying circus. This professional daredevil, half a mile in the air, stood on the top of a plane made slippery by the rain, poised part of the time on one leg, and when the second plane approached over his head, he seized its wing by one hand, and swung gracefully over.

The rain-soaked plane, however, very nearly ended Wilson's two-year career. While the planes were jockeying for position the first time they flew over the stands, Wilson temporarily lost his balance on top of the slippery plane and fell flat.

Minneapolis Pilot Participates.

Added daring was given to Wilson's act yesterday through the fact that the lower plane, from which he swung, was driven by Ray Miller, a Minneapolis pilot who had never practiced the feat. Ray Goldsworthy, who ordinarily pilots the lower plane, was caught in a heavy rainstorm near Mason City, Iowa, and got here too late for the show.

WOODEN LEGS SAVE TWO FROM DROWNING

JULY 11, 1921 *MINNEAPOLIS TRIBUNE*

Hildy! Get me rewrite! This front-page story is a confusing mess, one replicated by the Associated Press in versions appearing in a half dozen or so papers around the country. Despite the flawed description and a misspelled surname, the story line itself is plausible. Leroy Rodda, the accidental hero of the piece, lost both legs below the knees in a train accident at the Adams iron mine in Eveleth in 1910. According to family lore, he was trying to pull a drunk off the tracks when he was hit by a locomotive. After that accident, he took a job as a night watchman for the city of Eveleth, married and had three children. He and his wife built and ran Deer Horn Resort on Lake Kabetogama in the late 1930s.

LEGLESS MAN SWIMS TO SAFETY; WOODEN LIMBS SAVE 2 OTHERS

Gilbert, Minn., July 10.—While Harry Woodard, a good swimmer, was drowning, Roy Rhodda [*sic*], minus his two wooden legs which became loosened when a boat occupied by five men overturned, swam 300 yards to shore. The three others in the boat also swam to safety.

The drowning took place in Ely lake near here this afternoon during a log rolling contest. The five men rowed out in the boat to gain a point of vantage. When they dropped a heavy anchor overboard the boat began filling with water. All of the men jumped into the lake and started for the shore. Woodard swam 50 yards and sank while 2,500 persons looked on. His body was recovered three hours later.

William Brown, Eveleth; Leslie Star, New London, Wis., and W.J. Ulrich, Duluth, were the three others in the boat. Rhodda told witnesses that two of his companions utilized the floating wooden legs as life preservers.

ST. PAUL WOMAN SETS PARACHUTE RECORD

July 11, 1921 *Minneapolis Morning Tribune*

You've heard of Charles Lindbergh. How about Phoebe Omlie?

Both were born in 1902, and both began their remarkable aviation careers after graduating from Minnesota high schools. Lindbergh's solo crossing of the Atlantic Ocean landed him an enduring place in history. Omlie, who set several early aviation records and was once described by the Washington Post as "second only to Amelia Earhart Putnam among America's women pilots," died in relative obscurity.

Phoebe Fairgrave Omlie's passion for flying took hold in September 1919 during her senior year at St. Paul's Mechanic Arts High School. President Woodrow Wilson was in town to promote his League of Nations. The presidential motorcade passed near the school, accompanied by three military biplanes soaring overhead. She watched from a classroom window as the planes paused to perform aerial stunts. She was transfixed and transformed. "That's what I want to do…this is it!" she later recalled thinking. "And from that moment hence my eyes have never been out of the heavens."

By the following summer, she was spending her Sundays at Curtiss Field, a short airstrip near Larpenteur and Snelling Avenues, to watch planes take off and land. After a few months, yearning for a chance to fly, she offered to buy a plane and asked for a demonstration flight. The salesman said she would need to pay $15 for a ride, with the money going toward the purchase price of $3,500—about $46,000 in today's money.

She didn't have $15 with her, let alone $3,500. In the months since graduation, she had saved only a few hundred dollars working a series of unsatisfying office jobs. She eventually turned to her mother for help, assuring her of the profit potential of exhibition flying. In

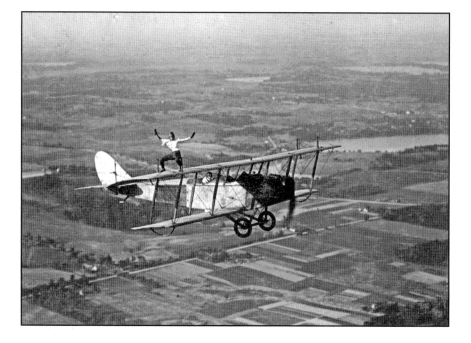

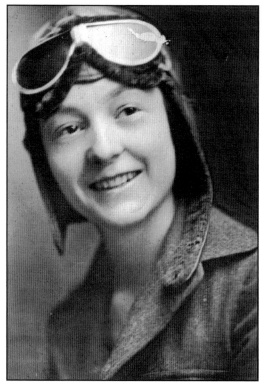

Above: With future husband Vernon Omlie at the controls, Phoebe Fairgrave hooks her toes under a wire on the upper wing and braces for a series of stunts. *P.W. Hamilton,* Minneapolis Tribune, *courtesy Memphis Public Library.*

Left: Phoebe Fairgrave Omlie. *Library of Congress.*

January 1921, using money her mother and stepfather had been saving to purchase a tavern, Phoebe bought her first plane, a refurbished Curtiss JN-4D.

A strict repayment schedule meant she needed to start earning money quickly. Flying lessons would have to wait. First she learned to perform aerial stunts, wing walking and parachuting. In her first parachute attempt, in April 1921, she landed in a tree, dangling but unhurt.

On July 10, 1921, she climbed out onto the wing of a Curtiss Oriole biplane nearly three miles above the Twin Cities. She stepped off, opened her chute and landed, twenty minutes later, in a field in north Minneapolis. Her 15,200-foot jump earned her a place in the record books and a spot on the Minneapolis Tribune's *front page. The paper misspelled her maiden name as "Fairgraves"; it has been corrected to "Fairgrave" throughout.*

18-YEAR-OLD ST. PAUL GIRL SETS WORLD RECORD
BY 15,200-FOOT PARACHUTE JUMP FROM PLANE

Phoebe Fairgrave, an 18-year-old St. Paul high school girl, who had not ridden in an airplane six months ago, yesterday broke all existing records for women parachute jumpers, when she leaped from a plane at a height of 15,200 feet over North Minneapolis, and landed safely 20 minutes later in a field about a mile from New Brighton. The jump was made shortly after 6 p.m. and was observed by hundreds of city residents.

The record-making jump, 4,200 feet higher than any made before by a woman, came after the Curtiss Oriole plane, piloted by V.C. Omlie, had climbed steadily for 65 minutes, from its starting point at Curtiss field, Snelling and Larpenteur avenues, St. Paul.

At 10,000 feet the girl and her pilot began to feel the cold. As they still climbed upward, out of sight of the ground, the cold intensified, and they were both [numbed] when the time came to jump.

"I wasn't afraid to jump," said the girl after she had landed safely, "but my hands were so cold that I hated to walk out on the wings. But I got out all right and fastened on my chute. Then I just let go and the wind carried me off.

"For the first 100 feet, I fell like a flash. Then the chute opened out and I began to swing back and forth through the air, as if I were in a swing. The motion, and the rapid change from icy cold to heat, sickened me at first. But at 12,000 feet I began to feel better.

"At 9,000 feet I struck an air pocket and dropped quickly again, but was soon out of it. The planes kept circling around me and made me feel less lonesome.

"I dropped to the ground so easily that I wasn't even shaken. It was just like jumping from a 10-foot wall. The planes couldn't land, but an automobile picked me up and I rode back to the field."

Miss Fairgrave was extraordinarily calm and unexcited after her experience and refused to believe she had done anything particularly brave.

"But isn't it terribly warm?" she asked. "Up there it was freezing and down here it is almost 100."

The new record-holder is just five feet tall, and weighs a little less than 100 pounds. She was dressed for the jump in an army uniform, [olive drab] riding breeches and an aviator's coat. Wrapped twice around her, she wore an inflated automobile inner tube against falling into a lake.

FOLLOW-UP: After the jump, Phoebe Fairgrave teamed up with her pilot, Vernon Omlie, for a barnstorming tour of the Midwest. They married the next year and then spent another grueling and dangerous summer crisscrossing the country, earning barely enough to cover expenses. They decided to quit barnstorming and settled in Memphis, Tennessee,

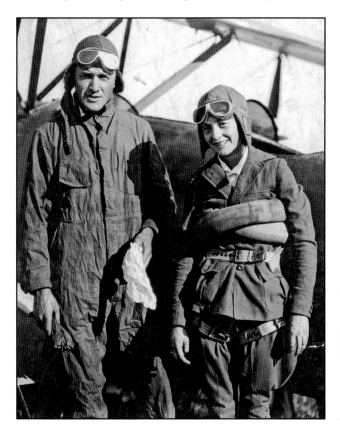

Vernon Omlie and Phoebe Fairgrave before one of her parachute jumps. A partly inflated inner tube was wrapped around her chest in case she landed in a lake. *Memphis Public Library.*

an early hub of aviation. Vernon taught Phoebe to fly, and together they established a business offering flight lessons, mechanical services and plane rides. They later added aerial photography, charter flights and crop-dusting to their list of services.

In 1927, Phoebe Omlie became the first woman to earn an airplane mechanic's license and the first to earn a transport pilot's license. She competed in cross-country races, won major trophies and set a world altitude record for women, reaching 25,400 feet in 1928.

Her success as a pilot led to a series of government posts. After his inauguration in 1933, President Franklin D. Roosevelt appointed her to the National Advisory Committee for Aeronautics. She quit the position in 1936 after her husband was killed in a plane crash in St. Louis. She took a year off to campaign for Roosevelt's reelection and then developed the curriculum for Tennessee's new civilian pilot training program.

In 1941, she returned to Washington and won appointment to the Civil Aeronautics Administration, where she was put in charge of establishing a training program for airport ground personnel. In just eight weeks, she set up more than one hundred schools in thirty-eight states. She also directed the establishment of scores of flying schools around the country.

Frustrated by increasing government regulation of the aviation industry, at age fifty she left the Civil Aeronautics Administration. She bought a cattle farm and, later, a small café and hotel in Mississippi. Both ventures failed. She earned some money as a public speaker, but after many years out of the aviation spotlight, she found that demand for her services was limited. She spent her last five years in Indianapolis, destitute and in declining health. On July 17, 1975, Phoebe Fairgrave Omlie, seventy-two, died of lung cancer in St. Vincent's Hospital in Indianapolis. She is buried next to her husband at Forest Hill Cemetery in Memphis.

DON'T MESS WITH MRS. MICKELSON

October 3, 1929 *Minneapolis Star*

Was Mrs. Michael Mickelson, the hero of this story, indeed the featherweight women's boxing champion of the Northwest in the mid-1920s? Alas, the early days of women's boxing are not well documented, and the Star*'s failure to report Mrs. Mickelson's first name complicates the search. I can find no evidence that such a title even existed. But this much is certain: Mrs. Mickelson had a powerful right hook and wasn't afraid to use it.*

MASHER GETS MASHED;
SEEKS SAFETY IN JAIL
FROM WOMAN BOXER
"PUT ME WHERE SHE CAN'T GET AT ME," VICTIM BEGS POLICE

The masher got mashed.

This particular masher, John Frederickson, 3036 University avenue S.E., is nursing 180 pounds of contusions and abrasions and lacerations in the city jail today and wondering what brand of luck led him to make [a move on] the sister-in-law of the former women's featherweight boxing champion of the northwest.

Mrs. Michael Mickelson, 220 S. Seven and One half street, who six years ago was acclaimed as the champion of all women featherweight boxers in the northwest, went to a theater at Seven Corners with her 14-year-old sister-in-law, Inga Mickelson. Mrs. Mickelson, besides being a champion, is the wife of Patrolman Michael Mickelson of South Side police station.

When Mrs. Mickelson and her sister-in-law came out of the theater, they became separated. Suddenly, Mrs. Mickelson heard a scream. A man had

Seven Corners (Cedar Avenue and Washington Avenue South) in about 1925. *Hennepin County Library Special Collections.*

accosted Inga near the theater. Mrs. Mickelson rushed to the scene, and although it has been six years since she has indulged in boxing, she swung a pretty right to the masher's jaw.

He staggered and raced away, with the former champion at his heels. Years of roadwork and training came to her assistance and enabled her to keep up with the fleeing man.

At Fifteenth and Washington avenues S., he dodged into the lobby of a hotel. Mrs. Mickelson dashed after him and cornered him.

Masher Badly Pummeled

Meanwhile, Inga called police. When a squad of patrolmen reached the hotel, they found the 180-pound masher on the floor, his face mashed and bleeding, and writhing in agony, and the former woman featherweight champion standing victoriously over him.

"Thank the Lord you've come," whimpered the masher when he spied the patrolmen. "Take me away from this woman right away. Put me in jail where she can't get at me."

MINNESOTA'S BIGGEST BABY

July 18, 1936 *Minneapolis Star*

One summer night, I was browsing Minneapolis Star *microfilm from July 1936, looking for stories about that steamy month, one of the hottest on record in the Upper Midwest. I found plenty of interesting news about the heat wave, but I also spotted this eye-popping front page featuring a "life-size" photo of "the largest baby ever born alive" in Minnesota. Baby Boy Schmitz, later baptized Jacob, tipped the scales at just under sixteen pounds. Holy Toledo!*

The Minneapolis Star *covered the story intensely for several days, reporting on almost every angle of the unusual birth, the mother and father, their farm and Jacob's dozen siblings. The paper even published photos of an average-size boy born about the same time in a Minneapolis hospital so that readers could see just how big this Schmitz lad was.*

A 2006 interview with one of Jacob Schmitz's siblings follows this initial report by the Star*'s Nat S. Finney, who went on to win a Pulitzer Prize in national reporting at the* Minneapolis Tribune *in 1948.*

State's Huskiest Baby Tips Scales to 16 Lbs.
Mother and Son Doing Well After Battle by Doctors to Bring Infant to Life After Birth

By Nat S. Finney
Staff Writer for the *Star*.

Graceville, Minn.—Baby Boy Schmitz, weight at birth 15 pounds, 15.2 ounces, height 24½ inches, head 16 inches, chest 17 inches, across shoulders 8 inches, July 16, 1936, Western Minnesota hospital.

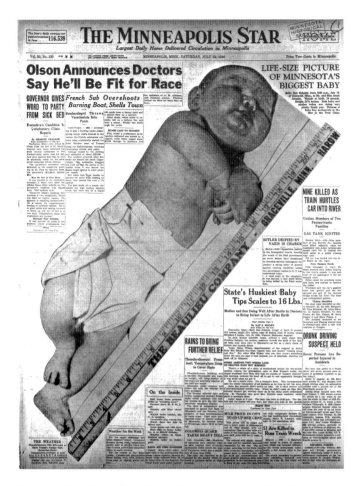

Even at reduced size, the *Minneapolis Star*'s front page featuring a "life-size" Baby Boy Schmitz is breathtaking. The yardstick from a Graceville hardware store was a nice touch. Star Tribune *microfilm*.

In such laconic scientific terms, without a word about Mrs. Veronica Schmitz, the mother, medicine records the birth of the largest baby ever born alive in Minnesota—as far as a day's check of doctors and records shows.

Today Helen Wilson, superintendent of the hospital at which Baby Boy Schmitz was born, reports baby and mother "coming along just fine." But when Miss Wilson tells you that, there's something about the way she says it that reminds you of somebody cheering his head off in whispers.

Stork Arrives Two Weeks Late
To Deliver Baby Boy Schmitz

There's a whale of a story of motherhood behind the dry-as-dust medical reports, the professional calm of Miss Wilson's words, the simple statement that Baby Boy took six ounces of "nursery mixture" this morning, hollered his head off to get it, and apparently thought it was swell when he got it.

It's not a man's story. It's a woman's story. This correspondent asks the kindly indulgence of all mothers as he tries to tell the story.

Baby Boy Schmitz didn't arrive on time. He is what doctors call a nine-and-one-half months baby. When he didn't come on time Mrs. Schmitz' doctors got worried—later on in the story you'll understand why. So Thursday they gave Mrs. Schmitz some medicine which starts a mother's labor.

Labor began at 6 p.m. The baby was born at 9:30 p.m. The doctors and the nurses tell you that; but when you look at the records of the hospital you discover that three doctors and three nurses attended the birth of Baby Boy Schmitz.

Three Doctors, Three Nurses
Get on the Job in a Hurry

The doctor in charge (you can't use his name because of the ethics of the medical profession) is a tall, strong chap. He started the delivery with one nurse assisting him, Miss Rose Boylan. Half an hour later he called desperately for another doctor and another nurse. They came as fast as they could.

Another half an hour and an emergency call for another doctor and another nurse was sent out. They came. Then for an hour and one-half the six of them worked to bring Baby Boy Schmitz into the world alive. Mothers will understand that. There isn't much that a man can say.

When Baby Boy Schmitz was born he wasn't, properly speaking, alive. Life was there, ready to start, but it couldn't start by itself. The tall doctor who had charge put it plainly this way: "They have to cry, you know. You have to make them cry."

So the tall doctor, tired, half-prostrate from the extreme prairie heat in the delivery room, went to work. He worked for an hour and one-half to get life to really start in that great baby—the largest ever born in Minnesota alive.

He used the prone pressure method of artificial respiration.

"I breathed for the baby with my hands," he put it. "You place your hands on the baby's back like this, and press. Then you release the hands quickly. You keep that up until the baby breathes for itself. It was hard because my arms were so tired."

He used hot and cold water baths—quick changes between hot and cold, calculated to shock Baby Boy Schmitz into life.

USES ETHER BATHS,
ALSO SPANKS BABY

He used ether baths. The instant evaporation of ether gives the baby a sensation of extreme, burning cold. He used an injection of a drug called coramine. He spanked Baby Boy Schmitz. Slapped him. Jounced him.

And after an hour and one-half life took a firm grip of Baby Boy Schmitz. Life's clutch stopped slipping, so to speak. Baby Boy Schmitz settled down to some steady crying. Then slept, breathing peacefully. Then woke. Then howled.

"You get to know that howl," Miss Wilson chuckled. Then when she saw this writer didn't get it at all, she said: "Men are pretty dumb. What I mean is that you get to know by a baby's crying when it's hungry."

It was just two and one-half hours after Baby Boy Schmitz' clutch on life stopped slipping that he woke up hungry.

"You can believe it or not," the tall doctor said, "but he took four ounces of nourishment—nursery mixture we call it.

YOUNG HUSKY EATS
AND THEN SLEEPS

"I stopped worrying about Baby Boy Schmitz right then. He has eaten and slept like a daisy since then." This nursery mixture is just high grade corn syrup, water and milk. Miss Wilson couldn't bother to say in what proportions. "Every mother knows about it," she said.

All this work over Baby Boy Schmitz leaves Mrs. Schmitz pretty much out of things. When Baby Boy was delivered, Mrs. Schmitz went to sleep.

"It wasn't as bad as you might think," she smiled Friday. "I think the twins were worse, and the boy that died—that was much worse, oh, much."

Mrs. Schmitz, sandy-haired and hazel-eyed, shook hands and smiled at callers. She's a real woman, a big woman. She's five feet 11 inches tall and "weighed" 190 pounds before the baby was born. She has a warm, grand smile, and a soft, strong voice.

There is about her both twinkling good humor and deep, warm calm. She's 37, and this was the fifteenth time she has been in child bed.

The Schmitz family in July 1937. *Top, from left*: Mrs. Schmitz (holding Veronica), Vivian, Valeria, Donald, Reinhart, Eugene and Mr. Schmitz (holding Vernon). *Just behind Jacob, from left*: Louise, Laura, Katherine and Betty. *From the* Minneapolis Star.

MOTHER ANXIOUS TO
GET BACK TO GARDEN

"I'm tired, of course. And this hot weather bothers me. But I really feel perfectly all right. The only thing that worries me is that I've got to get back to my garden. This hot weather has spoiled so many things, and we've got to have vegetables to can and cabbage to put down."

Later Mr. Schmitz said that last year Mrs. Schmitz put up 850 quarts of vegetables and two barrels of kraut for the winter. And most of it's gone. It takes a lot to feed 12 children and a baby, and the Schmitz family, what with conditions that affect farmers with 200 acres of land in western Minnesota, doesn't have even pennies to kick around. The farm is near Dumont, Minn.

WORRIES ABOUT SKUNKS
GETTING HER CHICKENS

Mrs. Schmitz does a job that would make many a woman faint just at the description of it. She has—now—13 children to care for. Her kitchen garden

looks to be a little more than one acre, and she and the youngster care for it. She has a large flock of chickens—"they are mighty important these days," she says, "and I hope the skunks don't get the chicks while I'm away."

Mrs. Schmitz' home has some conveniences—not many. It would seem desperately few to city mothers. And then, to top it all off, Mrs. Schmitz helps her husband in the field when the rush of harvesting is on. That is, she has in the past; and she sees no reason why she shouldn't this autumn.

"Not for harvesting," she laughs, "but later. I'm all right, you know."

Jacob Schmitz, six-feet-four-inches in his sox, lean and tanned, just turning 40, denies the size of the babies comes from his side of the family.

Thinks Baby's Size
From Mother's Family

"Unusual births are in Veronica's family; I mean in Mrs. Schmitz' family. She was part of one the like of which I never heard. She was a twin. She was born at nine months. The other twin was born at six months. I've talked to a lot of people and I never heard of a case like that, did you?"

Jacob Schmitz explains his wife's maiden name was Veronica Cordie, and she was born near Richmond, Minn. "Her father was French and her mother German. The red hair (he patted Eugene's red top as he said it) and the freckles come from her side, and I guess unusual births do, too."

Then Mr. Schmitz tells you about the twins. They are, barring only his strapping youngest son, who won't be named till Mrs. Schmitz is ready, the apple of his eye.

"The twins weighed 11 pounds and 15 ounces for Vernon and 9 pounds and 15 ounces for Veronica. That's pretty near a record, too. We even got a letter from President Roosevelt congratulating us on the twins."

Other Children All
Were Big When Born

The twins and Baby Boy aren't the end of the unusual birth story, either. Before the twins were born a baby boy that died weighed 14 pounds. The one doctor that tried to deliver the child at the Schmitz farm couldn't get help there in time, and the baby died.

Then there's Elizabeth, now 3, who weighed 12 pounds at birth; and Katherine, now 6, weighed 11 pounds—a pretty big baby girl. The rest of the living children are Laura, 8; Louise, 9; Eugene, 11; Reinhard, 12; Donald, 13; Vivian, 14; Valeria, 15, and Victor, 18. Seven of them are in school at Dumont. Victor, the eldest, hopes to get into a CCC camp this fall.

Mr. Schmitz and his wife regard their family as nothing unusual. The country around Graceville is pretty new country, and large families aren't unusual in new country.

"We have our troubles taking care of them all," Mr. Schmitz says. "But they're all perfectly healthy. Never have to call a doctor.

"For a while in 1934 when we lost our stock because of the drouth, the going was pretty bad. I guess we'll make out this year, but it's pretty bad now."

FOLLOW-UP: I interviewed one of Jacob's younger brothers, Dave Schmitz, in 2006 and again, briefly, in 2015. He's now seventy-five years old. He and his wife, Carole, live in Wheaton, Minnesota, and have been married for fifty-three years. They have two adult children, six grandsons and two great-granddaughters.

Dave's weight at birth? "Eleven and a half pounds."

Memories of Jacob: "We called him Junior. Outside the family, he was Jake… One of the things I really knew him for and respected him for: He had a handicap [from a form of polio that struck at age five] and never let it get in the way. He was loved by every single person that knew him.… [His illness] left him with shakiness of the hands. He'd grasp something and have a hard time holding it. He had a hard time eating. He tried to cover it up. Nobody cared, but he did. It left him with a slight stagger."

Still, Jacob did his share of work on the farm. "He could fix things," Dave said. "I can see him painting some of the old machinery Dad had. He was handy. He did a lot of things for a kid who had a handicap."

Did you rib Junior about his birth weight? "We used to tease him about being the famous one. He was the kind of guy to just shrug that off."

Did the fame translate into money for your family? "My folks always said they never got a dime" from Junior's story.

Jacob Schmitz at age twenty-one. Star Tribune *archives.*

97

Your mom must have been special. What do you recall about her? "When you mention Mom, the word that pops into my head is how fussy she was, keeping the house nice, and how hard she worked…We'd stand in a line before going to school. You had to pass inspection. You didn't get out of the house until she checked your nails and ears…We'd didn't have a lot of modern conveniences. She was very, very fussy about cleanliness…

"She was a very good cook, did a lot of canning. It was not uncommon for us to go into winter with 1,200 to 2,000 quarts of food. Like tomatoes or beans. It would take like two, three jars to feed the family. You had to open up enough to feed eight to twelve people plus friends, relatives, a threshing crew. She'd go out with two dishpans full of sandwiches to feed the threshing crew. One kid would carry the water, another the sauce. It was all things that took work. She canned all this stuff. It was just awesome how that woman worked."

Memories of Dad: "He was a giant of a man. He was 6 foot 4. He ruled the roost. He never, never, ever struck you. When he hollered, you just froze in your tracks. He wasn't a mean guy. He had a way with his tone of voice that could just make you stop in your tracks. Very stern, but very fair. He made sure that he explained things to all of you. …

"He had a lot of friends. He wasn't the kind of guy who went up town and hung around and used the bottle. He abstained from alcohol and never smoked. He had some brothers who struggled with alcohol…If the teacher chewed your butt in school and called him because you did something wrong, you'd be more worried about him than the teacher."

After high school, Jacob attended the State School of Science in Wahpeton, North Dakota, for two years. "He wanted to be a schoolteacher," Dave said. "I think the funds ran out. He was the only child to attend college."

Jacob went on to work for the Traverse County Highway Department. "He was a handyman," Dave said. "He kept things clean, made coffee. Also worked in sales, rototillers, things like that. He used his own rototiller to till gardens to make an extra buck."

In 1967, he suffered a cerebral hemorrhage and died in his bed. He was thirty years old.

"Junior owned his own house," Dave said. "He was renting out the bottom and stayed upstairs. He was a kid that was proud to be somebody. Everything that he had he acquired through hard work and a lot of guts…I was at home when I got the call that my brother Reinhart had found him. It was probably one of the worst days of my life. We were good buddies. We talked a lot. We were really a close-knit family."

GOLF CHAMP PATTY BERG AT 20

SEPTEMBER 26, 1938 *MINNEAPOLIS STAR*

Minneapolis native Patty Berg, who took up golf at age fourteen and went on to win eighty-eight pro and amateur tournaments, was a founding member of the Ladies Professional Golf Association. In this story, the Star *caught up with her for an interview at her parents' home two days after she won her first national title, the U.S. Women's Amateur. She was twenty years old.*

LINKS WARS OVER
PATTY BERG GETS SOME REST
CHAMP BACK HOME
LIKED THE CAMPAIGN, BUT LIKES TO GET HOME TO HER OWN BED
FRIENDSHIPS WHILE PLAYING MORE FUN THAN CHAMPIONSHIPS, SAYS PATTY AFTER HER BIGGEST YEAR

She has fashioned the greatest win streak in the history of women's golf in these United States.

She has started 13 times this year and come home a winner 10 times.

She performed a feat Saturday equaled by only two others.

She won the National Women's golf title by a 6 and 5 score just after turning the corner into the adventuresome twenties.

But all Patty wanted to talk about was the mechanics of registration at the University of Minnesota.

Tomorrow she will move to the university along with some 1,500 others and become a full-fledged freshman.

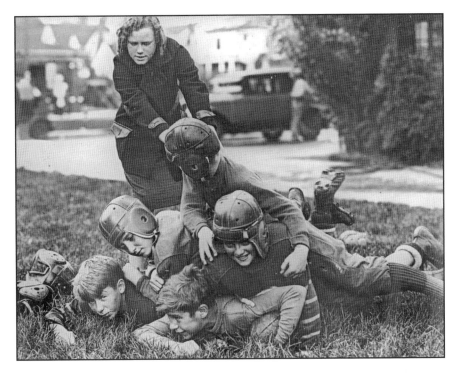

Above: Before her father steered her toward golf, Patty Berg quarterbacked her neighborhood football team in south Minneapolis. The caption on the back of this well-worn photo noted her age—"about 13"—but failed to identify the boys in the pile. *Star Tribune* columnist Sid Hartman confirms that football legend Bud Wilkinson is in the center of the photo, grinning at the camera. Sid had this to say about Berg: "She was an amazing lady. She made women's golf what it is today." She also remembered to send Sid a Christmas card every year for fifty years. *Minnesota Historical Society.*

Left: "The real kick I get out of the tournaments now," said Patty Berg after winning her first national golf title at age twenty, "is the opportunity to get together with my golfing friends, meet new ones, and the sociability it all means. I like the thrill of competition and like to win as much as anybody, but friendship right now is more important." Star Tribune *archives.*

That's her big moment right now and, relaxing at the home of her parents, Mr. and Mrs. Herman L. Berg, 5001 Colfax avenue S., for the first time in five weeks, she was far more excited about that than being the first Minneapolitan to win the women's title.

She's going to enroll in the College of Science, Literature and Arts. Her favorite study is history. She's just a bit dubious about her university interests, however, because most of her pals are at private schools. But from now on it's classwork, with golf only in interludes.

Wednesday night she'll be honored by her home club, Interlachen, at a victory dinner. On Oct. 5 the junior Association of Commerce and other civic organizations will toast her at a citywide celebration.

Then she will settle back and forget pretty much about golf until she swings into the winter play. The extent of that depends upon her dad and "coach." She knows she won't play in as many tournaments as she has the past year.

"It's too tough," she explained.

PLAYING ALL YEAR

It has been just one endless round of tournaments for her since she started competitive play soon after the first of the year in Florida.

And now that she has established such a phenomenal record, has the whole business palled on her?

"Not at all," she explained. "I wouldn't care if I won another thing. I still would be as thrilled. The winning is only incidental.

"The real kick I get out of the tournaments now is the opportunity to get together with my golfing friends, meet new ones, and the sociability it all means. I like the thrill of competition and like to win as much as anybody, but friendship right now is more important.

"As a matter of fact, I like the practice rounds more than the actual tournaments. Then we get together, and really have a great time. Some might get the impression that there is a bitterness in this tournament business, but there isn't. For instance, Mrs. Estelle Lawson Page, the defending champion whom I was lucky enough to beat Saturday, had her locker right next to mine, and we had a great time all week—yes, right through the championship match, too.

"You can emphasize that luck, too. I just happened to have more of it this year than the rest. Or maybe it was my faith in '13.' I was born on Feb. 13, you know, was playing in my 13th tournament, won on the 13th hole Saturday."

While winning 10 of 13 tournaments, including 45 match play rounds and three medal meets. Patty is 45 strokes under women's par for the whole distance. In the National Women's meet last week she was 11 under women's par in the match play rounds and five under regulation figures for the entire week.

The young lady has taken on remarkable poise since she won the state women's tournament at Rochester last June.

The personable Patty has lost 11 pounds, is down to a low for her of 124, which she intends to build up.

School Has Thrills

But now it's school—and one more thrill, her biggest to come. She's looking forward to seeing her "kid" brother—six feet one—play football at Washburn high school.

And she wouldn't be surprised if she saw those Gophers, too. Because, you know, football was her first love, until her father called her off from the corner lot game with the boys, and she turned her mind to golf.

WILLIE PEP AND THE HORMEL HAMMERER

July 26, 1946 Minneapolis Tribune

Willie Pep, the longtime featherweight champion who won 229 professional boxing matches, traveled to Minneapolis in July 1946 to take on Austin's Jackie Graves, the "Hormel Hammerer." In his book In This Corner, *Peter Heller suggests that Pep deliberately tried to avoid hitting Graves in the third round, to see if he could "impress the judges solely with his ring smarts." Sporting fact or fiction? The third round is not even mentioned in this* Tribune *sidebar, in which top-ranked Pep heaped nothing but praise on Graves, who was ranked No. 2 in the world by* The Ring *magazine that year.*

CHAMP HAILS JACKIE
GRAVES CAN BEAT ANYBODY—WILLIE

BY FRANK DIAMOND

"He's a tough kid…it was a tough fight. I hit him as hard and as often as I've ever hit anyone. Yes, he has the style to beat any featherweight in the business, including Phil Terranova."

So spoke a great world champion, Willie Pep, as he nursed his bumps and bruises in his dressing room after knocking out Jackie Graves in the eighth round at the Auditorium Thursday night.

"No kidding," said the modest champion, "he hits like an ax. That's what I told Lou [Viscusi, his manager] after the second round. I said, 'I can't let that guy hit me. He'll knock my brains out.'"

Jackie Graves, also known as the Austin Atom, won the Minnesota featherweight title in 1944 in only his seventh professional fight. *From the Minneapolis Times.*

Viscusi and trainer Bill Gore nodded in agreement. Viscusi then added, "Graves is much better than we thought. I'm sure he'll lick any featherweight in the business."

As for the Hormel Hammerer, his face was red as a Hormel ham. He was discouraged but not disappointed. "Now I know how a champion fights," he mumbled out of puffed lips. "There is nobody tougher than Pep. I hope he gives me another chance in the future."

All this time Jackie kept rubbing his injured left hand which caved in under the impact of the blow which staggered Pep in the second round. Manager Len Kelly looked at it and mumbled something about putting [it] in a cast

today after a doctor examines the injury which is above the first knuckle and extending over the thumb toward the wrist.

"He'll probably have to rest until September," said Kelly. "Maybe even until Stecher decides to run again in late September or early October."

The gate, largest in the history of boxing in Minneapolis, grossed $39,254.40. It netted $29,444.53. Pep's 35 per cent was good for $10,305.58 while Graves' 25 per cent equaled $7,362.13. Not bad pay for two kids, neither of whom is more than 23 years old.

Graves started the fight with two strikes against him. First Pep, using a champions' prerogative, took over Graves' "lucky" dressing room, and that nettled Jackie. Then Pep jumped into the ring first and took Graves' "lucky" corner. This so irked the Austin youngster he refused to get into the ring until Pep switched corners. But Pep, still standing on a champion's right to

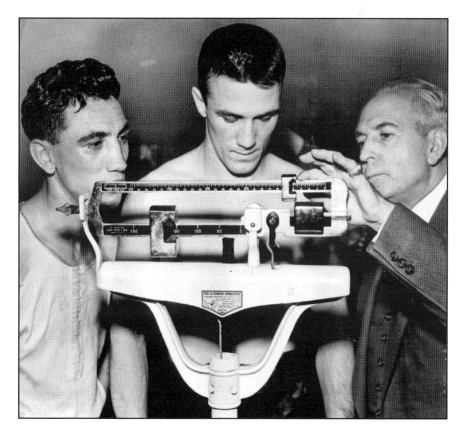

Jackie Graves weighs in before a bout with Eddie Dumazel (left) at the Minneapolis Auditorium on January 29, 1948. Graves knocked out the Welshman in the first round. *From the* Minneapolis Times.

choose his own corner, refused to budge and Jackie was forced to migrate into strange territory.

Both Harford, Conn., writers here to cover the fight agreed that Graves was outclassed from the start but fought back gallantly and hit Pep as often and harder than any of Pep's other 104 opponents.

Their big thrill was when Graves rose from his knees to put Pep on his knees in the thrilling never-to-be-forgotten sixth round in which Graves went up and down like a hotel elevator during an American Legion convention.

One of the oldest fans at the fight was Dan Gainey's 80-year-old father of Owatonna.

Was it tough to get tickets? Ask the hundreds of fans who milled outside the Auditorium until 10 p.m. refusing to give up the quest. Or ask Bernie Bierman, who spent all day Thursday trying to buy three tickets.

Jay Hormel, Jackie's boss at the Hormel plant, had balcony seats. Among the "visiting press" was Mayor H.H. Humphrey.

Loneliest room in town after the fight was room 408, Dyckman hotel. That was the room Kelly had reserved for a "victory celebration."

Pep was to leave today for Buffalo, N.Y., where he has a new car waiting for him—"either a Chrysler or Oldsmobile, whichever I want."

WILLIE MAYS "TORRID" IN MINNEAPOLIS DEBUT

MAY 2, 1951 MINNEAPOLIS MORNING TRIBUNE

Just a year out of high school, nineteen-year-old Willie Mays took the field for the Minneapolis Millers on May 1, 1951, opening day at Nicollet Park. More than six thousand fans watched the rookie notch three hits and make a "sparkling catch" against the flagpole, according to the Tribune's account of the rain-shortened 11–0 victory over Columbus. Another future Hall of Famer, Hoyt Wilhelm, was the winning pitcher that day. Two weeks later, the New York Giants called up the hot-hitting Mays and made him their center fielder.

"MUDDERS" OVERWHELM COLUMBUS 11–0
MAYS IN TORRID DEBUT, DANDY RAPS FOUR HITS

BY HALSEY HALL
MINNEAPOLIS TRIBUNE SPORTS WRITER

The Minneapolis Millers captured the first Black Mush Bowl game in Association opening history Tuesday.

Before 6,477 soaked but happy customers, they downed the Columbus Red Birds 11–0 in 6 2/3 innings of cavorting on a diamond that nearly required two successive triples to score a run. The whitewasher was Hoyt Wilhelm.

Willie Mays said howdy-do as bombastically as any newcomer in history. He got three hits, made a sparkling catch against the flagpole, unfurled a typical throw.

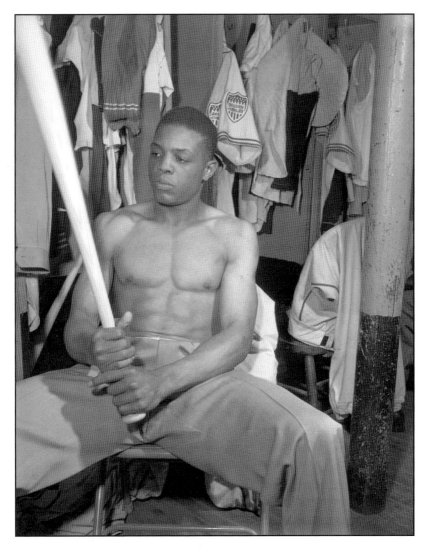

Newcomer Willie Mays had a firm grip on things in the Millers clubhouse. *Star Tribune archives.*

Ray Dandridge, just a little worried about his pal, possibly, belted four hits, including a home run that gave him a watch from the National Jewelry Co. Jake Early came along and did the same thing, minus the watch.

Let's not forget Wilhelm in the penchant to talk about hitting. He gets credit for a five-hitter as he outhurled starter Herb Moford. The seventh inning counts as played, which meant the fourth hit for Dandridge, since the Millers were ahead in their half when umpire Pat Padden called the game.

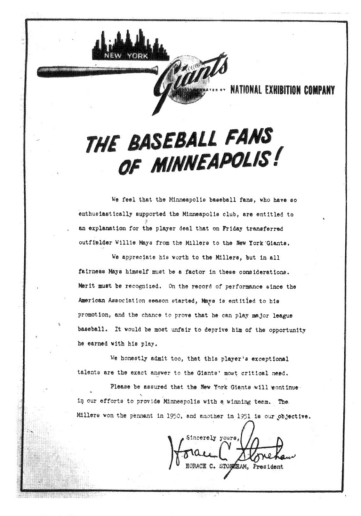

New York Giants owner Horace Stoneham must have felt some heat from fans of his AAA farm club when Mays was called up after less than a month. Stoneham placed this ad in the *Minneapolis Sunday Tribune* a few days later, explaining to all of Minneapolis that the kid deserved a shot. Star Tribune *microfilm.*

THEY WEREN'T offering jewelry for walks, a sore spot with Dave Williams. Davey strolled four-for-four, which was the easy way, considering the perfectly abominable condition of the field.

The contest was over right in the first inning, which is about as quickly as you can work for a victory in a home-opening game. The Millers got three. Pete Milne walked, Mays singled to center, the boys moved up as Mike

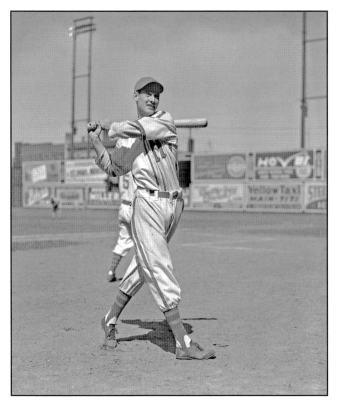

Left: Other future Hall of Famers played for the Millers, including Ted Williams, Orlando Cepeda and Carl Yastrzemski. Williams, pictured here, batted .366 and hit forty-three home runs for the Millers in 1938. *Minnesota Historical Society.*

Below: The Minneapolis Millers called Nicollet Park home from 1896 to 1955. The little ballpark at Thirty-first Street and Nicollet Avenue also hosted boxing matches, high school football games and other events. *Minnesota Historical Society.*

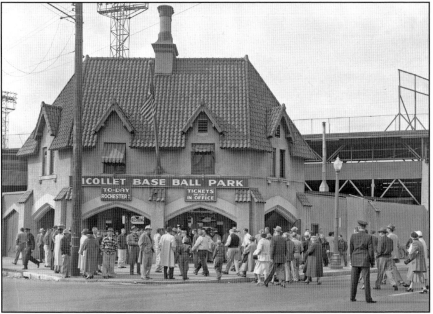

Natisin rolled and the little veteran named Dandridge brought them in with a single to left. Moford grew generous and passed Williams, Johnny Kropf and Early in succession to force Dandy across.

It was slow going. Moford was wild, and Wilhelm was cautious, but you couldn't be exactly sprightly in the bowl of soup that was Nicollet's diamond. The Millers aroused themselves again in the third for a foursome with Dandridge opening on a single.

Williams walked and so did Early to load 'em up. Mr. Wilhelm, who sometimes has been known to "pull" a ball as far as second base, didn't bother about it this time and sliced a runway double to right. Milne's single to center and his forceout by Rudy Rufer closed the quartet.

MARTY GARLOCK had come in during the round and Marty granted four more in the sixth, when Dandridge opened by home-running for a watch. Once more Williams walked. Kropf doubled and Early, a bit

New York Giants manager Leo Durocher (left) arrived in Minneapolis for an exhibition match with the Millers in June 1955. Along for the bus ride from the airport were center fielder Willie Mays and pitcher Paul Giel. Giel, a two-time All-America football player for the University of Minnesota, played three seasons for the Giants. *Wayne Bell,* Minneapolis Tribune.

peeved about it all because he wasn't first with the idea, slammed one clear over Nicollet avenue.

Dave Thomas, the Faribault boy, came in for the seventh after Wilhelm had pitched out of a bases-filled hole by fanning the pesky Howie Phillips. It was over with Dandridge on first and two out in the bottom half.

So tonight there's an arc light contest at 8:15, which reminds the lights were on yesterday afternoon too for the first time at Nicollet.

HOW TO PLAY THE
"NOBLE GAME" OF MARBLES

MAY 10, 1953 *MINNEAPOLIS SUNDAY TRIBUNE*

Any older person can tell you (and will tell you, with some regularity) things were better back in the day. This was true as far back as 1953. In a letter to the editor, a Tribune *reader explained the proper way to play marbles:*

MARBLES AS PLAYED IN CITY 40 YEARS AGO WAS A REAL "SPECTATOR" SPORT

To the Editor: For many years a gross historical inaccuracy has existed, perpetrated, I believe, by newspapermen nostalgic for their lost boyhood. I refer to the game of marbles.

In picture or description even during the heyday of the robust game of marbles as we played it, marbles has always been portrayed as a mamby-pamby affair with boys (or even girls!) hunched around a circle, shooting marbles between thumb and forefinger. I never played it, but I doubt that 100 marbles could change hands all day in such a pastime.

To that generation now between 40 and 50, reared on the north side in Minneapolis (possibly the south side was too effete for the game) marbles began long before the vernal equinox. With snow still on the ground, but as soon as it was warm enough for us to get our hands out of our short pants pockets, we would play "hits and spans." You would throw a marble out 5 or 10 feet and your opponent would try to throw another marble close enough to hit yours or within a hand span of it. If he failed

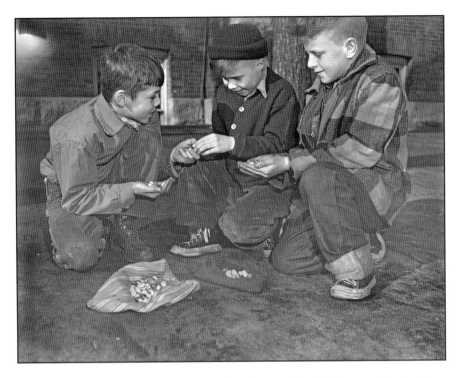

Three boys count their marbles after an evening of competition in Minneapolis in April 1953. *Minnesota Historical Society.*

it was your turn. A hit or a span won the other marble—really not much of a game.

Then one day in March or April a patch of dry sidewalk would appear here and there. Hundreds of little boys would come down out of trees, crawl out of tents or caves, or retreat from walking on the rubbery ice of lakes, ponds or the Mississippi river, and the real marble games would begin. From two to 50 boys might be in a game. Inexpensive, small, baked clay marbles (10 or 15 for a cent) were rolled at agates, steelys or flints. We would roll from three to five sidewalk squares away for agates (1 for a cent) and sometimes so far you could hardly see them for flints (worth up to a quarter). Rules were simple: you rolled marbles until you hit the agate or flint, and then your opponents did likewise until marbles or time were gone.

The boy with the agate would place it cunningly behind a crack or unevenness in the sidewalk. On the bumpy surfaces agates were hard to hit. The lad with the agate would sit with his legs astride to capture the marbles as they rolled in. Marbles that leaped the outstretched legs or which rolled to either side were fair prey of lads temporarily out of marbles. With four

or five boys rolling, sometimes two marbles would hit the agate at the same time. The resulting arguments often ended in fist fights which were even more enjoyable than the marble game.

We played our smaller games involving six or eight boys near our homes. Only a few agates and 200 or 300 marbles were involved. The big games were played on West Broadway where the older "tough kids" congregated. Dozens of boys and thousands of marbles were in the continuing game.

Passersby good naturedly walked around the maddening crowd of young enthusiasts.

You could come into a game with a thousand marbles and leave destitute, or you could pirate a few strays, get into the game and come away with all the marbles. Skill, chance, effrontery, good sportsmanship and downright thievery were all included in marbles as we played. It was a prelude to the competition in adult life, and anyone large or small, strong or weak, could play. Its effects, salutary or invidious, are remembered today by men, be they derelicts or senator. And to think, for shame, that a conspiracy of the press has kept our children from even knowing about this noble game!

—J.K. MacKenzie, Minneapolis.

LAKERS WIN SIXTH TITLE
IN SEVEN YEARS

APRIL 13, 1954 MINNEAPOLIS MORNING TRIBUNE

In 1947, an ambitious twenty-seven-year-old sports reporter, Sid Hartman, persuaded a few local businessmen to buy the Detroit Gems and move the moribund franchise to Minneapolis. For $15,000, the new owners got some old uniforms, six player contracts and, later that year, the first-round pick in the National Basketball League's dispersal draft. The team used that pick to land George Mikan, a six-foot-ten center who had been playing in a competing league that folded that fall. Along with six-foot-four forward Jim Pollard, another future hall of famer, Mikan led the young franchise to six pro titles in its first seven years in the Twin Cities.

The 1954 title was the Lakers' last in Minneapolis. Mikan and Pollard retired a few years later. A group of local investors led by businessman Bob Short bought the team for $150,000 in 1957. Three years later, Short moved the franchise to Los Angeles. The National Basketball Association would not return to the Twin Cities until 1989, when the Minnesota Timberwolves joined the league as an expansion team. The expansion fee that year: $32.5 million.

LAKERS SMACK NATS 87–80
FOR SIXTH TITLE IN 7 YEARS
POLLARD ACE IN CLINCHER

BY GLEN GAFF
MINNEAPOLIS TRIBUNE SPORTS WRITER

Paced by the brilliant Jim Pollard, the old pro, the Minneapolis Lakers defeated the gritty Syracuse Nats 87 –80 Monday night to become champions of professional basketball for the sixth year in their seven-year existence.

A crowd of 7,274 saw the Lakers take charge early and keep up the pace to defeat the Nats four games to three in the final playoff. It was their third straight National Basketball association title.

THE VICTORY was also worth $7,500 to the Lakers and ran their playoff pay to $17,500.

Pollard, fairly well shackled in previous games with the Nats, was unstoppable last night. The only charter member of the Lakers still in action scored 21 points and was the guiding genius on the floor for the Lakers.

The battered Nats, who had done what many said was the impossible by forcing the playoffs to the final game, just couldn't match the Lakers' strength, power and finesse last night.

Minneapolis broke in front 8–7 and was never headed. It was appropriate that Pollard hit the jump shot (his first basket of the game) which put the Lakers in front to stay.

FROM THERE Minneapolis steadily increased its margin. At the quarter it was 17–14; at the half it was 38–32. In the third period the Lakers broke it wide open, once leading by 16 points, and were in front 65–54 going into the final period.

It was in the third period Sunday that the Lakers had scored only six points to allow the Nats to get out of the hole and eventually win the game on Jim Neal's shot at the end.

But last night it was different. Minneapolis rolled in 27 points and boosted its six-point half edge to 61–45 with 3:13 to play in the period.

SYRACUSE WAS able to cut it back to 66–58 early in the fourth period, but Minneapolis stepped away from that with ease.

The Lakers went into a semi-stall in the fourth period, forcing the Nats to pull out. This allowed the Lakers to break in repeatedly for easy set-ups.

Dugie Martin took over in the fourth period with his dribbling acts.

George Mikan was limited to two field goals and 11 points, but he was a power on the boards, grabbing 15 rebounds. Clyde Lovellette tossed in 14 points and latched on to 13 rebounds.

EVIDENCE OF the way the Lakers overpowered the Nats was the tremendous edge in the rebound department where Minneapolis grabbed 56 errant shots to only 38 for the Nats.

Pollard did a good defensive job on that Nats' Dolph Schayes, holding him to two field goals through the first three quarters. Schayes broke away in the final period, however, to top the Nats with 18 points.

Paul Seymour, who had done such a tremendous job of stopping Pollard in the previous six games, came up with 16 points.

SALT IN VERNE GAGNE'S EYE

NOVEMBER 19, 1958 *MINNEAPOLIS MORNING TRIBUNE*

In the 1950s, before pro football and Major League Baseball arrived in the Twin Cities, pro wrestling had a foothold on the sports pages of Twin Cities newspapers. And Verne Gagne, once a standout athlete at the University of Minnesota, was king of the ring.

There's a lot to admire about old-time pro wrestling. As far as I know, grapplers did not use steroids or demand new arenas at public expense. But I can't get the rules straight. It was legal to give your opponent a ferocious eye gouge, sleeper hold or pile driver. But rub a little salt in the eye? That was cheating.

GAGNE WINS ON REVERSAL

Vern[e] Gagne was declared the winner over Mitsu Arakawa on a reversed decision Tuesday night before 2,988 fans at the Auditorium. The time was 22:15 in the one-hour time limit match.

The Japanese wrestler had felled the former University of Minnesota football star with his stomach claw hold, but referee Joe Valento reversed the call after Arakawa was said to have rubbed salt in Gagne's eyes.

Gagne pinned Arakawa initially with the drop kick but the referee was incapacitated at the time, having collided with the wrestlers.

It was when the referee was out of action that Mitsu employed his salt trick. Several fans along with the boxing promoters jumped into the ring to call attention to the violation.

In the semi-windup, Stan and Reggie Lisowski of Milwaukee defeated Tex McKenzie and Chet Wallich.

Verne Gagne, 225, Excelsior, won by reversed decision over Mitsu Arakawa, 238, Japan, 22:15.
Stan Lisowski, 254, Milwaukee, pinned Tex McKenzie, 275, Houston, 8:15; McKenzie
 pinned Stan, 10:40; Reggie Lisowski, 257, pinned Chet Wallich, 237, Hollywood, 6:10.
Bearcat Wright, 270, Omaha, pinned El Toro, 300, 13:50.

Joe Pazandak, 245, Medicine Lake, pinned Johnny Nellis, 212, Belgium, 12:20.

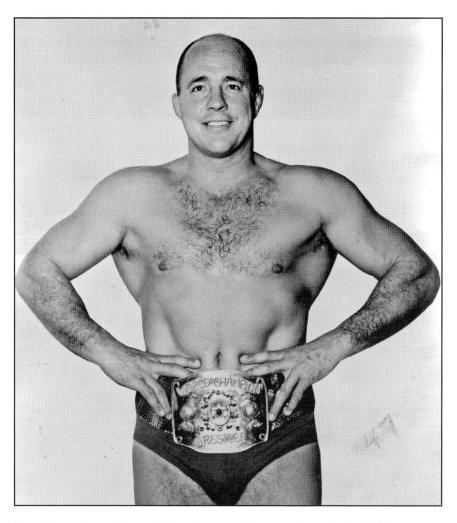

Verne Gagne, who was known for his quickness and finesse on the pro circuit, held the American Wrestling Association's heavyweight champion belt ten times. Star Tribune *archives*.

THE FIRST MIRACLE ON ICE

February 28, 1960 *Minneapolis Sunday Tribune*

More than fifty Minnesota men have won Olympic medals in ice hockey, including a future governor (Wendell Anderson), two future Stanley Cup winners (Neal Broten and Jamie Langenbrunner) and two future NHL Hall of Famers (Frank "Moose" Goheen and Phil Housley). The American team won bronze once (1936), silver eight times (the first in 1920) and gold twice (in 1960 and 1980).

A dozen Minnesotans were on the 1980 team, with St. Paul native Herb Brooks behind the bench. The team's "Miracle on Ice" upset of the Soviets at Lake Placid, New York, is well documented.

Outside the hockey world, the U.S. upset of the Soviets at Squaw Valley, California, in 1960 is less well known. Forwards Roger and Billy Christian of Warroad and goalie Jack McCartan of St. Paul were among eight Minnesotans on the roster. Brooks was the last player cut.

Sweden, Canada, Czechoslovakia and the Soviets were the pretournament favorites. As in 1980, the Americans were not widely expected to challenge for the gold.

Team USA won its first five games, including a 2–1 upset over Canada in the medal round, setting the stage for the game against the Soviets. The Tribune's *Dick Gordon captured all the nail-biting action for Sunday readers.*

U.S. Tips Russ 3–2 in Olympic Hockey
Bill Christian Nets Clincher

By Dick Gordon
Sunday Tribune Staff Writer

SQUAW VALLEY, Calif.—The amazing United States hockey team and incredible Jack McCartan did it again not to mention little Billy Christian who flashed the glory light for the tying and winning goals in a 3–2 comeback victory over Russia here Saturday.

As a result of this second straight hair-raising, heart-stopping triumph, the Americans are now one short step from their first Olympic hockey championship.

For a time it appeared the United States might win the hockey championship last night. Sweden took a 4-0 lead over Canada but finally the Canucks won 6–5. Had Sweden tied or beaten Canada, the Yankees would have won the title regardless of what happened against Czechoslovakia.

The only unbeaten team in this tournament, Coach Jack Riley's U.S. outfit stakes its 4-0 record against Czechoslovakia at 10 A.M. (Minneapolis time) today.

A TIE WOULD be enough to assure the Americans the title, since Russia has a tie and a loss against it and Canada a defeat.

But no one in yesterday's roaring, standing Blyth arena crowd of 9,000 could talk about the Czechs right now.

They were still thrilling in the first victory any American team ever scored over Russia. The U.S. bowed to the Soviets 4–0 in the 1956 Olympics, which the Russians won at Cortina, Italy. And in five other international games the best the U.S. could get was one tie last year in New York.

YESTERDAY, however, there were no doubts about the hustling supremacy of the heir apparent over the defending champion.

Only in the first period did the Russians dominate play, then their close checking stopped the U.S. attack and their passing bewildered the U.S. defense. Only fine work by St. Paul's McCartan kept the Russ lead down to 2–1.

But the rest of the way it was a different story. Through the last two sessions the U.S. fought their hearts out just as they did in the other upset—by 2–1—over Canada Thursday.

IN THAT STRETCH they outshot the Russians 23–12 for a 31–27 total edge.

Billy Christian, all 5 feet 9 of him, got the tying marker midway in the second period. Older brother Roger, another of Warroad's favorite sons, set up the play by carrying the puck up the middle and by all but one defender.

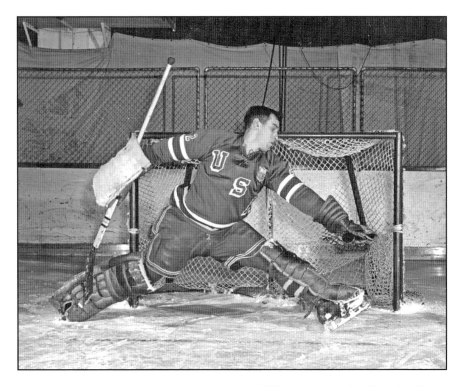

Jack McCartan, who tended goal for St. Paul's Marshall High School and the University of Minnesota, was among eight Minnesotans on the U.S. Olympic roster. Star Tribune *archives.*

Once across the blue line he slipped a perfect forward pass to 21-year-old Billy. By then Russia's agile goalie, [Nikolai] Puchkov, was out of his cage. And Bill drilled it into the open net from a difficult left-hand angle.

McCartan didn't have many saves from there on in, but those he did make were sensational.

Four separate times he stopped clean breakaways when a Soviet forward had only him to beat. Once he dove on the puck, and countless other times his teammates, like John Mayasich, were sprawling on the ice to freeze the tantalizing disc.

In this same span the U.S. was also having its chance. Early in the third period, Duluth's Tom Williams, one of eight Minnesotans on the title-hopeful squad, batted in a go-ahead goal from in front of the cage.

But it was ruled "no dice" because it was "deflected in by a stick more than four feet in the air."

Later Puchkov, wearing No. 13 on his back, lost his stick but a shot by Bobby Owen of St. Louis Park unfortunately struck a teammate.

And still the most under-rated team in the tourney wouldn't give up. At the 14-minute mark its tenacity around the boards kept the puck in the Russian zone for several minutes.

Roger Christian set up the payoff by passing to Williams who shot. Puchkov saved but the puck bounded clear and the other Christian was Billy on the spot right at the mouth of the goal. With 5:01 left to play the U.S. was ahead to stay.

Harvard's Bill Cleary shot the U.S. into a short-lived first period lead as brother Bob's check set up a loose puck in mid-ice. Unguarded Billy kept going with that opening and whizzed in a corner shot from 20 feet out.

BUT 59 SECONDS later, at 5:03 of the period, the 1956 champs had the equalizer, on a well-screened shot by Veniamin Aleksandrov. And some four minutes after that the Russ were sporting a 2–1 edge when [Mikhail] Bychkov deflected a long shot. The puck then bounced off McCartan's stick and dropped just inside the "counting" zone.

Perhaps it was a mistake by McCartan. But if it was, it's the only one he's made this tournament.

The game was full of contact but so clean that only five penalties were called—two against the U.S. and three against the Russ.

FOLLOW-UP: As in 1980, the U.S. victory set up a match against a team that proved difficult to dispatch on the final day of the Olympics.

The Americans, playing an 8:00 a.m. game at high altitude the day after the nerve-wracking victory over the Soviets, looked gassed. The Czechs, with a shot at a medal themselves, led 4–3 after two periods.

Enter Soviet captain Nikolai Sologubov. Literally. He visited the U.S. locker room before the final period, patting players on the back and shouting encouragement. More important: He suggested to coach Jack Riley that the team use oxygen. "Solly," as the Americans called him, even helped administer it.

Led by Roger Christian's three goals, the reenergized Americans exploded for six goals in the final period to secure a 9–4 win and their country's first Olympic gold medal.

"Solly helped us, all right," Roger Christian said after the game. "But it was the gold medal that spurred us on. Remember that."

TINY EDGERTON HIGH WINS BASKETBALL TITLE

MARCH 27, 1960 *MINNEAPOLIS SUNDAY TRIBUNE*

It's one of the most memorable achievements in the history of Minnesota high school basketball. More than a half-century ago, tiny Edgerton—population nine hundred—beat Austin 72–61 to capture the state title at Williams Arena. The Flying Dutchmen (27-0) showed great skill and heart during the one-class tournament, upsetting powerhouse Richfield in overtime in the semifinal before calmly dispatching Austin in the final.

The Tribune *sports section was packed with coverage of Edgerton's remarkable run. On the front page, though, was this charming little story featuring two of the team's "steady" fans:*

EDGERTON WINS TITLE, 72 TO 61
FANS COOLLY WATCH DUTCH BEAT AUSTIN

Saturday night was like a Buster Keaton silent movie for the fans from Edgerton.

They played it almost deadpan as their scrappy Flying Dutchmen coolly thumped Austin 72–61 in the finals of the state basketball tournament.

While a record 19,018 people packed smoky, hot Williams arena, stamping and screaming, the two girl friends from Edgerton quietly and nervously eyed their boy friends out on the court. Their calm reaction was typical of most of the folks from Edgerton.

"I'VE BEEN nervous all day," said Judy Roelofs, shyly showing her black onyx class ring, a present from her "steady," guard Darrell Kreun.

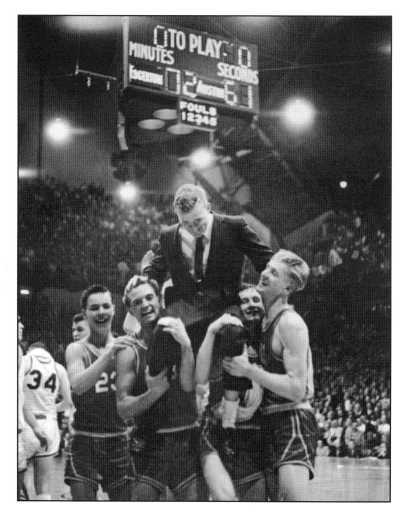

Edgerton players hoisted their young coach—Rich Olson, twenty-three—after winning the state title. *John Croft*, Minneapolis Tribune.

"I saw him today, but I didn't get a chance to talk to him," 16-year-old Judy sighed. "Fact is, I haven't seen him to talk to since last Sunday."

"Me, too," said the tiny (5-foot, 1-inch) blonde whose steady boy friend is 6-foot 4-inch center Dean Veenhof.

"But my being tiny and Dean's being tall is no problem," blushed cheerleader Joyce Zwart, 15, her head just reaching over the raised court from the front-row seat.

THE TWO girls and their boy friends double-date back in Edgerton.

Cheerleaders raced onto the floor at Williams Arena after Edgerton upset Richfield in the semifinals. *Paul Siegel,* Minneapolis Tribune.

"They drop us off first," laughed Judy, who plays baritone in the band.

She tugged at her tie—"to get some air"—in the humid arena. "Dad does the knot for me."

With her big horn at her feet, Judy nervously tweaked her nose, clapped and kept track of the score and fouls on a sheet of notebook paper.

OTHERS in the band stood up to give a little yell when their team scored a bucket, but Judy just made a little mark with her pencil.

Over to the side, little Joyce smiled and turned red every time her boy friend got the ball, swooped up and dunked it in.

"I've been going with Dean about a month and two weeks," she said.

She cupped her hands to her face and exchanged yells with the band as it swung into "Bleacher Boogie" and then the school song, "Wave the Flag."

"WE DON'T play more than a couple of songs a night," the girl with the clarinet behind Judy said in a matter-of-fact tone.

As the final seconds of the game ticked by, the crowd started stamping and rose to its feet.

But not the Edgerton band. They kept to their seats, waiting for the big trophies to be awarded.

"We'll have to build a new trophy case," smiled the clarinet player, Diane Kreun, a second cousin of Judy's boy friend. "The one we've got isn't big enough."

Members of the team, and perhaps some of its followers, will attend church today at Riverside Reformed church, 102nd St. and Nicollet Av., Bloomington.

Because of its observance of the Sabbath, the team does not plan to return home until Monday, and there will be no celebrations in Edgerton until then.

FOLLOW-UP: One of the double-dating couples, Darrell Kreun and Judy Roelofs, ended up getting married. I spoke with them by phone in February 2016, a little over a month after their fifty-first wedding anniversary. They live on a lake near Bigfork in northern Minnesota. He's a retired high school basketball coach and teacher. She's a retired piano teacher. They have three adult children and four grandchildren, all living in Minnesota.

What do they remember about the moments after the title game against Austin?

"It was sort of anticlimactic," said Darrell. "The big game was the Richfield game.... The Austin game was pretty easy, compared to the semifinals. We were pretty calm and collected. Never got too high or too low. We were a bit relieved."

"I don't [remember that game]," said Judy. "I remember the Richfield game. And I remember an interview with a *Tribune reporter before the final game. He had heard I was dating one of the players." That was news to her maternal grandfather. After reading the front-page story, he told a relative: "I had to read the* Tribune *to know who my granddaughter was going with."*

VIKINGS SHOCK HALAS, BEARS

SEPTEMBER 18, 1961 *MINNEAPOLIS TRIBUNE*

The Minnesota Vikings selected University of Georgia quarterback Fran Tarkenton in the third round of the 1961 NFL draft. A few months later, the rookie led the expansion team to a 37–13 victory over heavily favored Chicago in the first NFL game played at Metropolitan Stadium in Bloomington.

The Tribune's game story detailed Tarkenton's exceptional afternoon in relief of veteran George Shaw: 17 of 23 for 250 yards, four touchdown passes, one rushing touchdown, no interceptions. Two minutes into the second quarter, future offensive-coordinator-turned-whipping-boy Bob Schnelker scored Minnesota's first touchdown on a 14-yard pass from Tarkenton. The defense, led by Jim Marshall and Rip Hawkins, "hit savagely up front" and kept the pressure on the Bears all afternoon.

Aside from the disappointing attendance (32,236), the franchise was off to a great start. But reality soon set in for the team laden with rookies and veteran castoffs. The Vikings lost their next seven games and finished 3-11.

Here's an interesting sidebar published the morning after the big victory over Chicago. Note how classy the Bears were in defeat. No whining, no complaining—just matter-of-fact observations and praise for their opponents.

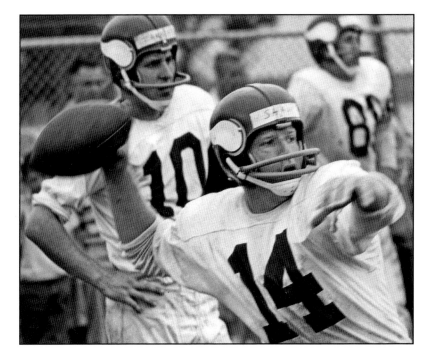

Future hall of famer Fran Tarkenton, then just a rookie, looks on as veteran quarterback George Shaw hurls one during the Vikings' first training camp in Bemidji in July 1961. *John Croft*, Minneapolis Tribune.

Bears' Coach Halas Says:
"Never Seen Anything Like It"

By Dwayne Netland
Minneapolis Tribune Staff Writer

George Halas slowly rubbed a vein-line right hand through wisps of white hair and shook his head in utter disbelief.

"I've never seen anything like it," confessed the owner-coach of the Chicago Bears, who had just absorbed a 37–13 National Football league loss from Minnesota's Vikings.

"Give the Vikings credit for capitalizing on our mistakes," Halas said. "But I have never seen so many things go wrong for a football team as they did for us today.

"I've been with the Bears for 42 years. In all that time I have never seen a center pass sail 10 feet over a punter's head in a league game. I saw it today.

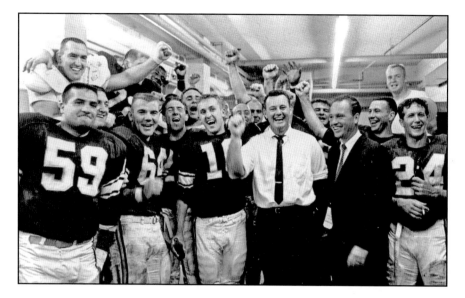

Beer and at least one cigarette were the order of the day as coach Norm Van Brocklin, quarterback Fran Tarkenton and the rest of the Vikings whooped it up after the team's first victory. Defensive back Rich Mostardi (far right) had the heater going. And that's Bert Rose, the team's general manager, in the suit. *John Croft*, Minneapolis Tribune.

"The pass interference call [on J.C. Caroline] right away started us off on the wrong foot. We never did get going. The entire first period was a comedy of Chicago Bear errors."

Then Halas stopped a moment, as if reminiscing through his own youth. "But how about those Vikings!" he said in obvious admiration. "They went out there with a purpose today. I can only imagine how Van Brocklin feels."

The moment the final gun had sounded, Halas shook off his gloom and raced over to shake [Norm] Van Brocklin's hand. "This is a big day for you," he boomed. "A big, big day. You'll never forget it."

Once over the shock of what happened to them, the Bears were able to offer an account of their dissection:

Rick Casares [fullback]: "I was scared to death before the game, feeling something like this could happen. The Vikings threw a bold challenge right at us in the first quarter, and we failed to meet it."

Dave Whitsell, defensive back: "On the long pass play on which Jerry Reichow scored, he bent in and then out. I had him covered, but then I lost the ball in the sun. He made a great catch."

Bob Wetoska, Minneapolis native [and DeLaSalle High graduate]: "I saw Fran Tarkenton get hit really hard several times, and he bounced up and gave it to us again. The guy's got guts."

John Adams, Bear punter who watched Ken Kirk's center fly over his head: "Kirk has never made a bad pass in his life. The first thing I recall was chasing the ball. I think that play gave the Vikings the lift they needed."

Kirk: "Nobody hit me at the snap. It was just a bad pass."

Herman Lee, tackle: "You could move a Viking out of a play, and the next second he'd be in on a gang tackle."

GOPHERS VINDICATED AT ROSE BOWL

JANUARY 2, 1962 *MINNEAPOLIS STAR*

The University of Minnesota was once a football powerhouse. Among its star players were tackle/fullback Bronko Nagurski; defensive tackles Bobby Bell and Carl Eller; quarterbacks Sandy Stephens and Tony Dungy; and halfbacks Pug Lund, Paul Giel and Bruce Smith. Smith is the school's only Heisman Trophy winner (1941).

The Golden Gophers claimed national titles seven times, the most recent in 1960. But that title bears a heavy asterisk: It's based on AP and UPI polls taken at the end of the regular season, before the Gophers fell to the University of Washington in the Rose Bowl and finished 8-2. Washington and Mississippi also lay claim to the national title that year. Ole Miss, ranked No. 2 in the final AP poll, beat Rice in the Sugar Bowl to finish the season undefeated.

The Gophers fielded another strong team in 1961, finishing the regular season with a 7-2 record. Undefeated Ohio State won the Big Ten title and an invitation to the Rose Bowl. But the Ohio State faculty voted to turn down the invitation, declaring that the school's emphasis on athletics was excessive. Sixth-ranked Minnesota was again headed for Pasadena for the New Year's Day game.

This time, the Gophers won, whipping UCLA 21–3. Star sports editor Charles Johnson, who had covered U football for decades, gave an appropriate nod to the team's golden years in the column reprinted here. It's the last time the Gophers have played in the "granddaddy" of college football's bowl games.

Warmath, Gopher Football Vindicated
Decisive Victory Heals Frustration of 1961 Rose Bowl

By Charles Johnson

PASADENA, Calif.—Murray Warmath and University of Minnesota football were vindicated here on this New Year's Day—yes, 100 per cent.

In our long association with football, we can't recall a situation in which a coach dedicated himself to atone for the past more than did this sterling citizen from Tennessee.

Warmath suffered for one whole year over the 17–7 defeat at the hands of Washington. He lived for the day when he could come back to the scene of that debacle to prove to the football world that he and his University team could do better.

Well, that day arrived here on New Year's Day, 1962, and what a day it was.

This was an occasion when the Gophers rose to heights that only Bernie Bierman and the Golden Gophers knew in the 1930s. They played old fashioned football. That meant grinding it out yard by yard but they did it in such a manner there was no doubt about the winner after the first six minutes of play had been completed.

So eager was Warmath to win and gain vindication that for the first time since he came to Minnesota he threw caution to the wind and played the boldest game he ever has asked his athletes to do during his in-and-out coaching career.

Imagine if you can, the Maroon and Gold athletes under this same Warmath never kicking until fourth down. Imagine if you can, the Gophers going for the yardage on last down no matter where the ball was. Imagine if you can these same Minnesota athletes passing deep in their own territory even when ahead.

Well the boys under Warmath did all of these things and got away with them.

So aroused was Murray that he almost inflicted a penalty on himself time and again by moving out on the field to protest decisions by officials who were too alert to his team's clipping, roughing and pushing.

Warmath wanted to come back to the Rose Bowl in the worst way even though he staked his coaching future with a second straight defeat, something that never has happened to any coach who has invaded the sanctum of this great football classic.

The 21–3 victory over the University of California at Los Angeles (UCLA) was a deserved reward to a man who has battled adversity, ridicule

and setbacks that would have broken the back of any individual with a weak spinal cord.

Maybe the Gophers didn't beat the best football team that ever played in Pasadena, but they overcame a gang that thought they could upset a Big Ten team for the second straight time.

So there should be nothing but salutes to Murray Warmath and his Gophers for a comeback that should set the pace for any efforts of this type during the year of 1962.

Well Scouted

LET IT BE SAID MOST definitely that by watching the motion pictures of previous UCLA games the Minnesota brain trusters did an exceptional job of learning in advance what the weaknesses of this particular foe were for this showdown.

Warmath and his board of strategy decided that the vulnerable spot in the UCLA armor was the right side of its line.

As a result, the able Sandy Stephens, enjoying the best day of his career in his swan song to college football, used his offensive weapons accordingly.

He made the most of his right halfbacks as they followed a gang of mates up front in clearing the way of opposing tacklers.

That meant that Bill Munsey and Jim Cairns had the biggest day of their collegiate careers. The former knocked off 41 yards in 10 carries and the Redwood Falls boy did even better with 45 yards in seven carries for the highest average of any player in the field.

Sandy Stephens, of course, was the man of the day. He sacrificed his own running talent at times to make the most of the weaknesses that he and his associates on the sidelines picked out as they viewed the progress of the action.

This was a game in which a Minnesota team made the fewest technical mistakes in its offensive operations of the entire Warmath era. Sandy picked out the soft spots in the enemy's front and took exceptional advantage of his observations.

It was due reward that Sandy was named player of the game and those who had picked him for almost unanimous All-America honors felt justified.

UCLA Humbled

IT IS SIGNIFICANT that in beating UCLA by a much more decisive score than the final count of 21–3 indicates, Minnesota humbled the Bruins of Los Angeles as hadn't been the case throughout the 1961 season.

The stout Gopher defense held the Uclans to a total gain of 107 yards—55 by running and 52 by passing. Not even the championship

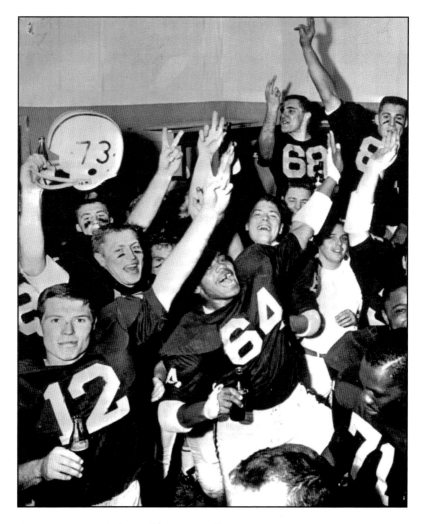

Backup quarterback Duane Biaska (12), offensive guard Roland Mudd (64) and
the rest of the Gophers celebrated in the locker room after their 21–3 victory over
UCLA. *John Croft*, Minneapolis Tribune.

Ohio State outfit did as well. The Buckeyes gave up 159 yards [in an
early season 13–3 victory over the Bruins].

UCLA has made five appearances in this classic and it has lost all of
them. Monday's setback was almost as decisive as that the school suffered
at the hands of Illinois in 1947 when the final score was 45-14.

The difference was that the licked Bruins didn't fall apart late in the game
yesterday as their representatives did in the inaugural of this series.

Penalties Heavy

THIS 21–3 VICTORY CAME in spite of the fact that the Gophers were hit hard by penalties. They were set back 70 yards on infractions compared to the opposition's five.

The penalties were for clipping, rough play, holding and other offenses.

However, this game might have been a rout if the officials had made one decision they should have. That was when Dave Mulholland went for a fair catch late in the third quarter. Before the Fargo boy had a chance to catch the ball, he was smacked from behind. He dropped the ball. The Bruins recovered and made their second drive of the day into Minnesota territory.

The Uclans used this break to get to the Minnesota 13-yard-line. Their second deepest penetration of the day. Here as in the first quarter, when the Los Angeles outfit went to the Minnesota six, the Warmath defense found itself equal to the occasion to stop the touchdown drive.

Terrific Line Play

MINNESOTA'S LINEMEN have had some great days under Warmath this year and last, but their supreme effort came in this vindication effort.

This was a day when the boys up front were just as good on defense as offense. Probably the best effort was on Munsey's touchdown in the second quarter that made the score 14–3. Led by Jim Wheeler the left side of the Gopher front wall opened a hole so big that even a sports writer might have cleared the distance.

Yet, it isn't fair to single out one man up front as the standout because this was a day when everyone who got on the field did his bit. It was a day when John Campbell at end was at his best on defense.

And Bobby Bell, All-America that he is; Carl Eller, hitting his season's high; Robin Tellor, Captain John Mulvena, Bob Deegan, Tom Hall and others performed gallantly.

The tipoff on how effective the Minnesota line play was came in the fact that the UCLA backs, speedy as they were, suffered 62 yards in losses during the afternoon. That total might have been more impressive if tackling in pursuit had been just a little better. There were times when the Bruins actually gained a few yards when they should have been thrown for stiff losses.

Minnesota's line set the pattern for the eventual victory when it halted UCLA's first scoring effort after the opening kickoff. The Bruins moved from their own goal line to the Maroon and Gold six.

Here on second down, Paul Benson held the dangerous Bob Smith for no gain. Then Tellor and Mulholland teamed up on third down to throw this same Smith for a six-yard loss. That forced the Uclans to make their

successful field goal effort from the 18 that gave them their only points of the afternoon.

It was the same story in the third period when, after Mulholland's fumble on a fair catch that he didn't have a chance to handle, UCLA started a serious threat.

The Bruins went all the way from the Minnesota 44 to the Big Ten team's 13. Here on fourth down, fullback Almose Thompson was rushed so hard on a spinner play by the Minnesota forward wall that he fumbled. The Bruins recovered the ball, but had to give it up because of failure to make the necessary yardage.

How can one speak better of a forward wall for those two gallant efforts on the only occasions when the boys had a job to do?

WELL EARNED SCORES

THE GOPHERS MADE three touchdowns in this comeback victory. All but one came the hard way.

They got a break when behind 3–0 in the first period when Judge Dickson recovered fullback Thompson's fumble on his own six. Munsey and Dickson knocked off five yards before Stephens dove over the UCLA right guard for the first touchdown. Tom Loechler made the first of three conversions.

In the second quarter, the Gophers began to grind it out. They moved 75 yards in 17 plays to make it 14–3. The longest gains were of 10, 12 and 14 yards on passes by Stephens to Dickson, Hall and Deegan. Otherwise it was two, three or four yards with Munsey and Cairns making the contribution.

In the fourth quarter, the Gophers, with victory assured, went 84 yards in 19 plays to make it a rout. There was only one pass play on this effort. That was a 14-yard to the same Deegan, who joined others in winding up an illustrious career.

UCLA's three points in the first quarter just barely got into the scoring column. It was Bobby Smith, who booted them from the 18-yard line. The ball barely got over the cross bar as it hung rather lazily in the sunshine.

Yet Minnesota's own penalties and their three fumbles kept this score from getting way out of hand.

BORN THIS WAY

AUGUST 19, 1962 *MINNEAPOLIS TRIBUNE*

In the summer of 1962, Sherri Finkbine, a Phoenix, Arizona Romper Room *host known as Miss Sherri, discovered that she had inadvertently taken thalidomide during her pregnancy. Fearing her fetus might be deformed, she decided to seek an abortion, first in Phoenix, then Japan and finally Sweden. Finkbine's story drew intense national coverage and prompted the* Minneapolis Tribune *to send a reporter to North Dakota to interview a twelve-year-old boy with the kind of birth defect that led her to seek an abortion.*

ARMLESS, LEGLESS N.D. BOY IS A "PRETTY LUCKY" YOUNG ATHLETE

BY JIM HICKS
MINNEAPOLIS TRIBUNE STAFF WRITER

BISMARCK, N.D.—While Mrs. Sherri Finkbine was in Sweden last week, Johnny Kemp—a boy she does not know—was in Bismarck, doing the things that most 12-year-old boys do.

He was eating his breakfast, brushing his teeth, playing third base for the Midget League "Milwaukee Braves," telephoning his friends, swimming and getting ready to work his Sunday newspaper route.

Mrs. Finkbine, from Phoenix, Ariz., underwent an abortion yesterday. She had taken the now-dreaded drug thalidomide, and she was afraid the child might be born without arms and legs.

Like Johnny Kemp.

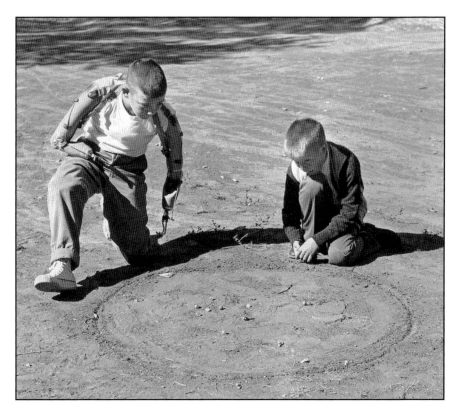

Johnny Kemp plays marbles with Phil Carufel, a neighborhood friend, in Bismarck in the summer of 1960. *Courtesy John D. Kemp.*

THALIDOMIDE was unknown when Johnny was born Oct. 10, 1949, and the stunted-limb deformities now being blamed on the drug were extremely rare. But Johnny's deformities, said his doctor, orthopedic surgeon Paul Johnson, are "exactly the same kind of thing" now afflicting thousands of newborn children whose mothers took thalidomide in early pregnancy.

Johnson described Johnny's condition as "congenital absences of portions of all four extremities." His arms end above the elbow, one leg above the knee, the other at the knee.

A wave of fear has swept the world since thalidomide has been blamed for an epidemic of deformities in Europe. In Belgium, a mother stands accused of murder for giving her new born, deformed infant an overdose of sleeping pills. Mrs. Finkbine's quest for an abortion has made headlines across the United States.

"THIS IS a little unfortunate," said John B. Kemp, Johnny's father. "The situation is not at all hopeless. It's far from hopeless."

"When Johnny was born that way," said Kemp, "it was just one of those things. Nobody knew why he came that way but we immediately elected to make a good home for him, to make him happy."

Johnny's mother died in 1950, leaving Kemp to care for Johnny and his two normal sisters.

By the time he was 3 years old Johnny was wearing artificial limbs. Learning to use them was not easy for the child.

"HIS FATHER did the right things," said Johnson. "Parents can be over-sympathetic. His father made him learn. He said, 'You put those on and you're going to leave them on.'"

At 7 Johnny was playing baseball. He now plays football and basketball, and caddies at Bismarck's Apple Creek Country Club.

Johnny had to work out some things for himself. He uses a catcher's mitt at third base and after much experimentation finally devised a way to hold it with his mechanical hands.

HE MUST grip his bat at almost the middle of its length, which means that he has to be almost on top of the plate when hitting.

"So what if I crowd the plate?" asked Johnny. "Some of those batters in the majors do too. Like Rich Rollins, he crowds the plate.

"Most of the other teams have caught on to how I hit, so they play up close. It makes me mad. I hit pretty well last year and I have been only one for 14 this season, because they know where I'm going to hit.

"Boy, someday I'm just going to line one right through them."

THERE ARE THINGS that Johnny has not learned to do. His attempts to ride a bicycle have been unsuccessful so far. "When I fall the bike comes down like a ton," he said.

"I don't care though. There are some kids that can't do anything. I think I'm pretty lucky to do all this stuff," he said. Two years ago he was the national Easter Seal boy and saw many children hopelessly crippled.

When school starts Johnny will be in the eighth grade at St. Anne School, where, he said, he is an average student ("They keep telling me my penmanship isn't too good.")

RIGHT NOW his goal is to improve his kicking in hopes of becoming a conversion specialist for Bismarck's St. Mary's High School football team in a few years.

"Dad said he'd buy me a pair of spikes if I kick all right this year," he said.

Johnny said he would like to become either a priest or a doctor, but right now his mind is full of baseball.

"I don't like the Yankees at all," he said. "But Mantle—with all those injuries, he can hardly run. I feel sorry for the guy, even though I don't like the Yankees."

FOLLOW-UP: More than 50 years later, John D. Kemp is president and CEO of the Viscardi Center, a New York–based network of nonprofit organizations that serves children and adults with disabilities. He is a nationally recognized expert on disability law and a cofounder of the American Association of People with Disabilities. Before joining the Viscardi Center, he was for ten years a partner with Powers Pyles Sutter & Verville, a Washington, D.C. law firm that specializes in disability issues.

Kemp, now sixty-six, joined the Viscardi Center and Viscardi School in 2011. He oversees a combined $25 million annual budget and 355 employees. The center was founded in 1952 by Dr. Henry Viscardi Jr., a leading advocate for people with disabilities who himself wore prosthetic legs.

Kemp recalls the first time he saw Viscardi, in 1959. At age ten, Kemp was chosen to serve as the national poster child for Easter Seals. Viscardi was the keynote speaker at an Easter Seals event in Chicago that year, and Kemp and his father were in the audience. "My dad looked at me and said, 'You can be like him.' I'm thinking, at nine or ten, 'whatever.'"

John D. Kemp, president and CEO of the Viscardi Center, is a nationally recognized expert on disability law. *Courtesy John D. Kemp.*

Fast-forward to 2010. A recruiting firm contacted Kemp about taking the top job at the Viscardi Center. He was reluctant at first. He was enjoying a fulfilling life in Washington and nearing retirement age. But Viscardi's outgoing chief executive, Edmund Cortez, persuaded him to visit the center. It was a compelling experience to see the transformation of so many people with severe disabilities. At age sixty-one, John Kemp and his wife, Sameta, made the move to Long Island.

"I'm now the fourth president of the center," he said. "It's an honor…I have been invigorated by these new challenges."

Before our first interview, in 2008, I e-mailed him a copy of the 1962 Tribune article. He'd never seen it before, and didn't recall talking to a Minneapolis newspaper reporter that summer. But he welcomed the chance to

"walk back through time" and hear again the voice of his father, John B. Kemp, who had died earlier that year at age eighty-nine.

"My dad was a very fair and loving man," Kemp said. "Very positive, very careful about ethics and commitment and hard work."

Being born with no arms or legs "is far from hopeless," he added, "and that's the way I was raised—my outlook on life was formed by my dad."

The story doesn't explain what caused Kemp's birth defect. Does he know more now?

"No, not much more," he said. "It was a birth anomaly. It was probably a morning sickness drug that my mother took, DES. Years later there was litigation, but we never thought about litigating it. My dad was all about moving on."

Despite his disability, Kemp's education was strictly mainstream, from elementary school in Bismarck, North Dakota, to high school in Frankfort, Kentucky, to college at Georgetown and law school at Washburn University.

How have prosthetics improved since he was a boy?

"Oh, my goodness," he said. "The materials have changed dramatically. They're much lighter weight and durable and functional. I wore thick leg braces then, and now I wear lightweight leg prosthetics, maybe 2 pounds each. Carbon fiber and a little bit of metal. My artificial arms are still very much the same as I was wearing back then. I still wear clamps. It's what I'm used to, and they're easy to repair."

Did he ever learn to ride a bike?

"No, I never did. I probably stopped right about then. I couldn't hold onto the handlebars and keep my feet on the pedals. I waited till I was sixteen and got a driver's license. I'm as bad a driver as anyone else—or as good."

How about high school football?

"No, I never learned how to kick well enough. But I was a student manager and earned seven high school letters for various teams, track, swimming and basketball" in Frankfort, where his family moved in 1963.

Since moving to New York, he has learned to love the Yankees. But he loves the Mets more. Iris Katz, wife of team president Saul Katz and sister of chairman Fred Wilpon, serves on boards that govern the Viscardi Center and the Viscardi School. "They are remarkably humble, caring and generous people," he said.

In photos, Kemp looks pretty fit. Does he still play sports, exercise, work out?

"I swim a lot, and I try my hardest not to gain weight," he said. "I like good food, good wine."

I asked him what advice he might have given that summer to Sherri Finkbine, the Romper Room *host whose thalidomide-related abortion prompted the* Tribune *to do a story about his life.*

He thought for a moment. "I would have said…it would have underestimated the value and quality of the child's life to terminate it before it had a chance to grow and develop.

[The abortion] *was a radical and unfortunate procedure. Life with a disability can be quite rewarding and fulfilling."*

He paused again. "I have had a fulfilling life…I didn't know then I would work in the disability field, and I have done that work all my life. It has been fantastic. I can't imagine doing anything else."

A STAND AGAINST
WHITES – ONLY HAMBURGERS

AUGUST 29, 1963 *MINNEAPOLIS STAR*

The Reverend Martin Luther King Jr. delivered his "I Have a Dream" speech on the steps of the Lincoln Memorial in Washington on August 28, 1963. One day later, the Star *told the story of a thirteen-year-old Minneapolis girl who was arrested earlier that month in Pine Bluff, Arkansas. Jean Webb's crime: she would not leave a McDonald's stand that had refused to sell her a hamburger.*

CITY GIRL, 13, GETS 30 DAYS IN JAIL FOR ARKANSAS SIT-IN

BY HERM SITTARD
MINNEAPOLIS STAR STAFF WRITER

A 13-year-old Minneapolis girl may have to interrupt her studies at Bryant Junior High School next month to stand trial in Arkansas for trying to buy a hamburger at a McDonald Hamburger stand there.

Jean Webb, daughter of Mr. and Mrs. McClinton Webb, 3244 Clinton Av. S., was arrested Aug. 5 by police at Pine Bluff, Ark., and spent two nights in a jail cell with 10 other teen-age girls before she was taken to Municipal Court.

The charge read to her in court was "refusing to leave a public place at the request of the management." She pleaded not guilty, was tried by the municipal judge eight days later and sentenced to 30 days in jail and a $500 fine.

She was released on bond and must appear in circuit court at Pine Bluff later to appeal the sentence. She returned here last week.

"I don't remember feeling any fear," Jean Webb Bradford recalled in a 2005 interview. "We were doing something important and it needed to happen. I felt more fear when my mother found out about it." *Jack Gillis,* Minneapolis Star.

Jean described her experience today. She went to Pine Bluff July 1 with her mother, brother and two sisters to visit their grandmother, Mrs. Will R. Wright.

"The Negroes there," Jean said today, "had been negotiating with McDonald's a long time because they could not buy hamburgers there. The manager, Robert Knight, told the Negroes he'd open his stand to them one day from 9 a.m. to 11 a.m. and from 2 p.m. to 4 p.m. But when the date came, he didn't open the stand.

"On August 5th, I was among 20 teenagers who went to his stand and tried to order. The manager asked us politely to leave."

She said they sat down at a table. "The assistant chief of police came with the paddy wagon then, and asked us to leave.

"We didn't leave; so he said 'you're under arrest' and took our names and addresses, and everybody got into the wagon and drove to jail.

"A model from New York who sat with us—a white lady—didn't know what was happening and she was arrested too. The policeman took our purses and they put 11 of us in a jail cell with two bunks in it.

"They put the 10 boys in one cell on the first floor.

"Six of us got out of jail August 7, because a Negro offered us bail money. The others had to stay in jail till Aug. 9.

"The judge asked us all to stand. He made a speech about him being the citizen judge of Pine Bluff. Then he said, 'I sentence you to 30 days in jail and a $500 fine.'

"The white lady got the same sentence."

While they were in jail, Jean said, they were taken to a room upstairs for photographs.

"They hung some numbers around our necks and took our pictures. We were fingerprinted, too."

Each of the prisoners was released on $1,500 bond.

Jean enters the eighth grade at Bryant Junior High School next Wednesday.

FOLLOW-UP: Jean Webb Bradford shared her memories of Pine Bluff in a 2005 interview. She was then an assistant principal at South High School in Minneapolis.

The sit-in at McDonald's was an event planned by leaders of the NAACP and African American churches in Pine Bluff. Her grandfather was part of a group that organized sit-ins in movie theaters and parks that summer.

Webb wasn't planning to get involved in acts of civil disobedience when she headed south. "I just went down there with my younger sister to visit my grandparents," she said. "My mother had instructed me not to get involved because of the danger."

Webb became interested in the civil rights movement in Pine Bluff through her grandfather. She joined a group of young people receiving training in nonviolent protest. The group visited the McDonald's twice and was refused service.

"They turned the hydrants on us," Webb said. "Another time dogs were released. I didn't get bit, but some did."

The group's leaders then met with restaurant managers and reached the compromise described in the article: blacks would be served if they visited the store at certain times. On August 5, about twenty people ranging in age from thirteen to about thirty arrived at one of the designated times and were refused entry. "We couldn't get in," Webb said. "They locked the doors and called police."

The actress mentioned in the article was nobody famous—"just a regular person"— and wasn't part of the group. "She was just trying to get a sandwich. She couldn't believe that this could happen in America." The woman talked to store management, pressing the group's cause, and ended up getting arrested herself.

The group sat outside the restaurant, singing civil rights songs. The police arrived and took everyone to jail. They were placed in two cells, according to sex. The white actress was housed in a third cell. The conditions were primitive: no food and just a hole in the floor for a toilet. Supporters brought them food during their three days in jail.

"I don't remember feeling any fear," Webb said of the McDonald's sit-in. "We were doing something important and it needed to happen. I felt more fear when my mother found out about it." Her mother was not pleased to hear of the arrest. After her release, Webb barely had time to eat and get cleaned up at her grandfather's house. "Me and my sister had to leave immediately. We were put on a train [to Minneapolis] that very afternoon."

Webb described herself as a typical kid growing up in Minneapolis, "taking piano lessons, ice skating." She ran for student council president in sixth grade. She doesn't recall encountering racism in those years, with one exception. She met with a white counselor at Central High to discuss college options and was asked why she would want to go to college. Her academic skills weren't in question; she was a solid B student. He refused to give her

any information about colleges. Later, she and her mother returned to the school and pressed the issue with the counselor, and he finally gave her the material. She went on to earn a bachelor's degree in sociology at Augsburg College and a master's in social work at Atlanta University of Social Work. She worked for Hennepin County for fourteen years before joining the Minneapolis school system in 1990.

Not many colleagues or students at South High know of her arrest in Pine Bluff. Occasionally, she speaks to classes studying the civil rights movement. Students are shocked to hear how she was treated. "They can't believe it," she said. "They say, 'Ms. Webb, why didn't you fight back?'" She explains how nonviolence was an effective tool of the civil rights movement.

What about that thirty-day sentence? Webb never served it. She's not certain what happened, but she suspects that a presidential order threw out convictions related to nonviolent civil rights protests. At any rate, her mother wouldn't allow her to return to Arkansas. Webb didn't visit Pine Bluff again until she was an adult.

TWINS FORCE A GAME 7

OCTOBER 14, 1965 *MINNEAPOLIS TRIBUNE*

In 1956, the melons and sweet corn grown on a 160-acre patch of Bloomington farmland gave way to a baseball stadium built to major-league specifications. The minor-league Minneapolis Millers played a few seasons at the new ballpark, Metropolitan Stadium, but the goal of civic leaders was to attract a big-league team. Washington Senators owner Calvin Griffith obliged, moving his franchise to the Twin Cities in 1961. The team's new name: the Minnesota Twins. The new logo featured a couple of somewhat pudgy-looking ballplayers, "Minnie" and "Paul," reaching across the Mississippi River to shake hands. The team won seventy games and lost ninety in its first season in Minnesota.

Just four years later, the Twins rode a high-scoring offense and a deep pitching staff to win the American League pennant. Six players—first baseman Harmon Killebrew, shortstop Zoilo Versalles, outfielders Tony Oliva and Jimmie Hall, catcher Earl Battey and pitcher Mudcat Grant—represented the Twins at the all-star game played at the Met that summer. Oliva won the American League batting title with a .321 average. Versalles was league MVP, Grant won twenty-one games and Killebrew, a future hall of famer, hit twenty-five home runs despite missing nearly fifty games with an elbow injury.

The Los Angeles Dodgers, Minnesota's opponent in the 1965 World Series, had a few stars of their own, including fleet-footed shortstop Maury Wills and two hall of fame pitchers, Sandy Koufax and Don Drysdale.

After winning the first two games at the Met, the Twins lost the next three in Los Angeles and needed a victory at home in Game 6 to avoid elimination. Groundskeeper Dick Ericson, seeking an edge for the home team, instructed his crew to dump seven wheelbarrows of sand on the base paths between home plate, first and second. The intent was to slow down Wills.

Los Angeles manager Walter Alston knew something was up.

"I read in the paper where the Twins were going to dump some extra sand on the field," he told reporters later that day. *"The players told me it was a little loose before the game. I asked the umpires to check it."*

The umpires inspected the field and told Ericson to scrape up the loose dirt. But the Dodgers, behind for most of the game, ended up attempting to steal only once, and failed. The Twins, less reliant on speed, blasted two home runs and cruised to a 5–1 victory. But Game 7 would be another matter. Twenty-four hours later, World Series MVP Koufax silenced the Minnesota bats and pitched his team to a 2–0 victory in the deciding game.

Although the Twins fell short that year, the Tribune*'s well-crafted account of Game 6, published on page one the next morning, is one fans can still savor.*

TWINS WIN, 5–1, TIE SERIES
GRANT, ALLISON BELT HOMERS

BY TOM BRIERE
MINNEAPOLIS TRIBUNE STAFF WRITER

Jim Grant—paid to pitch, not to hit—drew a standing ovation from a record-setting crowd of 49,578 for his home-run hitting in the Twins' 5–1 victory over the Los Angeles Dodgers Wednesday.

Grant pitched a snazzy six-hitter to even the World Series at three games each.

Now it's a one-game showdown at 1 p.m. today and the Twins have the home-field advantage at Metropolitan Stadium. So far the home team has won every game.

The weather forecast for game time calls for scattered light showers, not severe enough to disrupt the game for long.

Bob Allison, averaging .111 and almost benched, won his reprieve with a two-run homer in the fourth inning to break a 0-to-0 pitching stalemate between Grant and the Dodgers' Claude Osteen.

But it was Grant who turned the fans to hysterics with his three-run homer in the sixth inning.

"I'm really a pretty good hitter," Grant admitted with his usual postgame smile. He was the first pitcher to hit a home run in a World Series since Lew Burdette of Milwaukee in 1958.

It was the setting provided for Grant's first home run of the 1965 season that thrilled yesterday's throng at the Met. And World Series historians will

always blame Manager Walter Alston's ill-advised strategy for the Dodgers' sixth-game loss.

In the Twins' sixth inning, Allison drew a walk from relief pitcher Howie Reed with one out. Allison stole second base as Don Mincher fanned for the second out.

At this point, Alston ordered an intentional walk to right-handed Frank Quilici, a .200 hitter, preferring to hit to Grant, a good hitting pitcher.

The right-handed swing Grant whaled into Reed's first pitch. There was not a single doubt in the minds of the fans, the players and Alston. It was a 392-foot homer into the left-field pavilion.

"He hit a slider right down the pipe," admitted Reed after the game. "And I'll have to say he hit it pretty good."

Grant, an off-season song-and-dance man on the night-club circuit, fairly danced around the bases. He clapped a little for himself as he approached third-base coach Billy Martin, then jumped on home plate with both feet.

Thus the Twins, who established their reputation as home-run sluggers, defeated the bunt-run Dodgers by outhomering them 2–1 yesterday.

Los Angeles' lone run was a homer by Ron Fairly to open the seventh inning. The left-handed-hitting Fairly walloped Grant's 1-2 fast ball into the bullpen in right-center field—a 400-foot boundary belt.

The Twins were limited to only six hits by Osteen, Reed and Bob Miller. Osteen, the slender lefty, absorbed his first loss in seven decisions with the Twins. "I guess the law of averages caught up to me," he said.

A 21-game winner during the season, Grant ran his record to 2-1 in the World Series, adding a good breaking curve to his fast ball with perfect control. He did not walk a man and struck out five.

The Twins had all the early-inning chances while Grant pitched four no-hit innings.

Minnesota greeted Osteen with a first-inning single by Zoilo Versalles, but Joe Nossek bounced to the mound for a double play. Then Tony Oliva singled, and Harmon Killebrew grounded out. On the Twins' second chance, Earl Battey lined a "single" to left center, which center fielder Willie Davis missed on a diving catch. The ball also got by left fielder Lou Johnson. Battey lived dangerously and tried for three bases. He made it when the Dodgers botched up the relay, and was given credit for a triple.

So the Twins had a runner on third with one out, but they couldn't score. Allison struck out, for the seventh time in four games, on a curve ball. Mincher walked. Quilici was called out on strikes on a breaking ball.

Twins shortstop Zoilo Versalles stole second base in the sixth inning of Game 1, beating Jim Lefebvre's tag. *Dwight Miller,* Minneapolis Tribune.

Grant was not up to it yet. He popped high to shortstop for the third out.

The third inning was inconsequential. Versalles led with a walk and moved to second on Nossek's hit-run ground out. But both Oliva and Killebrew grounded out.

This brought up the fourth inning for Allison's moment of glory. Second baseman Dick Tracewski, noted for his fielding ability, erred on Battey's grounder.

Osteen threw two strikes to Allison, the second strike a beautiful fast ball low and away. On the next pitch, the Dodgers' southpaw wanted to throw a fast ball high and tight. Instead, it was letter-high over the plate.

And Allison hammered the ball 373 feet into the left-field seats for the Twins 2-to-0 start.

The Dodgers posed a momentary threat in the fifth inning on Fairly's leadoff single, then became serious in the sixth inning.

Tracewski made a bid for atonement by singling to left on Grant's curve ball. Pinch-hitter Willie Crawford struck out. With the infield in close, Maury Wills singled through the middle for his 11th series hit, one short of the six-game record.

Grant was equal to the task, however. Jim Gilliam popped out, and Davis flied out to center to end the inning.

After Fairly's seventh-inning homer, Grant granted a two-out single to John Roseboro in the seventh and a two-out single to Lou Johnson in the ninth. That was it.

WHAT'S HER LINE?
AGELESS CHARM AND ENERGY

SEPTEMBER 12, 1966 *MINNEAPOLIS STAR*

Elizabeth Gilfillan, a native of northern Minnesota, made a delightful appearance on What's My Line? *in 1952. Bennett Cerf, Dorothy Kilgallen and the rest of the panel were charmed by the wit and energy of the seventy-two-year-old contestant. She fooled the lot and earned fifteen dollars. Her unique line of work: she taught facial exercises to men and women interested in keeping their skin supple and radiant. Fourteen years later, still radiant herself, the New York entertainer was invited to bring her act to Minneapolis. The* Star *published this profile on 6B, the "Women's News" page.*

No Ol' Rockin' Chair for This Elder

By Suzanne Hovik
Minneapolis Star Staff Writer

*The rocking chair goes to and fro.
And makes you think you're on the go.
But keep off that ole rocking chair,
It won't get you anywhere.*

With a toss of her head at the idea of such props for the senior citizen set, an 86-year-old New Yorker sings and dances her way through a new life she created for herself about 20 years ago.

"There's something strange about me," Elizabeth Gilfillan will tell her audiences, mostly New York women's clubs.

"I'm a woman who doesn't mind telling her age. The older I get, the more valuable I'll be. I can hardly wait until I reach 90. I will do what I do now even better then."

What Miss Gilfillan does now is an informal act in which she plays the guitar, sings and dances, usually all at once.

And she gives delightful interpretations of humorous verse she has written—"My Eightieth Easter Outfit," "Who Wants an Old Age Pension," "No Old Age for Me" and "On Your Rocker."

These and others were recently published in a book, "Sensible Nonsense."

"I'm a woman who doesn't mind telling her age," Elizabeth Gilfillan, eighty-six, told a reporter. "The older I get, the more valuable I'll be. I can hardly wait until I reach ninety. I will do what I do now even better then." *Russell Bull,* Minneapolis Star.

In addition to these activities, she also teaches facial exercises, which she developed herself.

She recently completed a visit in Minneapolis with her sister, Mrs. Ernest Meilman, 130 Orlin Av. SE. And she was the guest of honor and entertainer at a luncheon by Mrs. Owen L. Johnson, 3203 E. Calhoun Blvd., who first saw Miss Gilfillan on the television program "What's My Line?" (facial expressions) 14 years ago.

Mrs. Johnson decided this spring to look up Miss Gilfillan and called New York. When the New Yorker said she would be in the Twin Cities in September, Mrs. Johnson made arrangements to meet her.

Miss Gilfillan was born in Minnesota. Her father was a missionary among the Indians in the northern part of the state. She left the state to attend Cornell Medical School, Ithaca, N.Y., and then graduated from the Sargent School of Physical Education.

"I used to be very shy," she explained. "I played the piano for a Russian dancing teacher for 46 years. I was beginning to think the job was permanent.

"Then I was asked to give a speech on the school's history. I tried to make it humorous, and I tasted success."

Miss Gilfillan at the time was 65 years old. "I wanted to entertain so I started preparing myself by taking voice lessons. They say I can be heard two blocks away when I want to be."

She said she also began exercising to "make myself more presentable." And she developed facial exercises at this time.

"I had studied at a school of physical training and I felt that if exercises could change the body, it could also change the face.

"As the face ages, the muscles shrink and unsupported skin falls into wrinkles. Exercising the muscles makes them thick again and brings back the original design of the face."

Miss Gilfillan said she doesn't claim the exercises perform miracles but most persons can shed 10 to 15 years.

"And if they start in the early 30s, they will never look old."

She added that another benefit from the exercises is improved circulation which gives the skin color and radiance.

"I teach men too, but they don't need the exercises. When they get older they look distinguished. Women look extinguished."

And, she added, "All my pupils are good looking. Otherwise, they wouldn't bother with the exercises."

GUMP WORSLEY STOPS 63 SHOTS

FEBRUARY 8, 1971 *MINNEAPOLIS STAR*

The Minnesota North Stars lured Lorne "Gump" Worsley, a future hall of famer and one of pro hockey's last unmasked goaltenders, out of retirement in 1970. As a young goalie growing up in that era, I marveled at this pudgy-looking old man who consistently frustrated the likes of Hull, Esposito and Cournoyer and kept the outgunned expansion team in many games.

I saw only a handful of National Hockey League games at Met Center back then and don't recall ever seeing Worsley play in person. My memories are based on radio and TV broadcasts and newspaper accounts. Minneapolis Star columnist Jim Klobuchar witnessed one of Gump's memorable performances on TV—and managed to eke out an amusing column.

HE IS NOW OFFICIALLY IMPOSSIBLE

FOR PEOPLE WHO GET their ice hockey over the air waves, the trick is to separate what is merely sensational from that which is truly unbelievable.

Hockey announcers tend to talk in code, particularly when they describe the agonized gymnastics of the goal keepers. I do not accuse them of insincerity or hambone theatrics. The trouble is the English language. There simply is not enough imagery in the old war wagons like "good," "great" and "incredible."

As a result, the hockey announcer faces the very real problem of trying to classify the level of incredibility at which the goalie is playing on this particular night.

This requires an advanced degree of restrained professionalism and subtle shading. Thus, when the announcer describes the save Tony Esposito has just made—use the workaday "flabbergasting" as an example—we know that Tony may have had to stick out a toe rather strenuously, but that he really wasn't breathing very hard.

If, on the other hand, the announcer discloses that the stop by Tony "bordered on the impossible and maybe even a little beyond," we realize immediately that there was character there even if the defenseman wasn't.

The ultimate challenge in the craft, however, is to make a superman out of Gump Worsley.

It's not that Gump Worsley of the North Stars is not a good goalie or even a great goalie. On certain nights, in fact, you might very well classify him as an incredible goalie and maybe a little beyond.

The dilemma confronting the announcer is that Gump just does not look incredible. Further, he does not act incredible. Gump is 41 years old. Admitted, this barely gets him out of puberty on the goalies' scale of longevity. To understand how productive hockey goalies may be at a mature age, you have to imagine Bernard Baruch in pads.

Gump, though, is a soul apart. There are goalies who cast a dramatic profile to the onrushing puck, such as New York's Ed Giacomin, and others who stand before the onslaught in an attitude of tragic torment, such as Cesare Maniago.

Gump resembles an unfrocked butcher who got mixed up in the neighborhood broomball game.

One of the things Gump does well is to enjoy the bouquet of good rye whiskey, at the appropriate times, of course. This discriminating taste, coupled with his squat dimensions and preference for loose tailoring, gives the impression the Gump may have a faint trace of credit union belly.

I have always considered this a slander on a good man with a low center of gravity. It ill fits one who is required, as a specification of his job, to be astounding and perhaps even incomprehensible on short notice.

So now here was Gump Worsley on the screen in Boston last night, and it was a spectacle I would conservatively describe as indescribable. The Bruins took 67 shots at Gump. He should have had a last smoke.

The narrator I listened to on TV was Hal Kelly, a moderate man in these things.

It was a joy to listen to an experienced tradesman at work. Hal opened by freely admitting that after 10 minutes of furious Boston attacks Gump Worsley was the master of the situation.

By the second period Gump was making a spectacular save now and then, and I frowned because I knew the Gumper was going better than that. "There's one," Hal erupted suddenly, "that was truly phenomenal."

Well, now. It was good to see the Gumper finally hit stride.

By the end of the second period Hal was flatly describing Gump as "supreme." This did tend to take a little of the edge off it when in the third period Gump made a stop on Derek

Gump Worsley fell to the ice unconscious after a shot hit him in the face in a 1972 game. Defenseman Tom Reid is at left. Star Tribune *archives*.

Sanderson. Having used up supreme, Hal had to retreat a little and simply observe that it was the kind of stop not only you and I couldn't believe, but that Sanderson couldn't believe, either.

THIS TENDED to make disbelievers of us all, but coming after supreme it seemed something of a demotion for Gump.

Anyhow, Gump is the last of the holdouts against the face mask. So it's possible to lip-read while he is lying there on the ice spewing and puffing. Hal has just called his last stop fantastic and I looked for a heroic quote from Gump.

"Balls," he is saying, "of fire. I find it inconceivable."

SOUTH'S ONE-EYED GOALIE MAKES COMEBACK

JANUARY 6, 1972 *MINNEAPOLIS STAR*

Minneapolis South High goalie Tony Julin, who lost an eye when a shot hit him in the face during practice, returned to the ice seven weeks later with a glass eye and a renewed determination to stop pucks. His greatest difficulty: the high shots. "I still can't get the angles right. And I don't always know where the net is," he said.

SOUTH'S ONE-EYED GOALIE MAKES COMEBACK

BY BOB SCHRANCK
MINNEAPOLIS STAR STAFF WRITER

As a Hill-Murray player skated in toward him Wednesday, South High School goalie Tony Julin slid smoothly to one side and blocked a shot.

It was just a hockey scrimmage with no score kept. But regardless of whether he stopped all the Hill-Murray shots, Julin was a hero to his teammates—just for being in the nets.

Julin has only one eye. He lost the other one in November when he had his mask off and a flying puck shattered it, necessitating its removal. It was replaced by a glass eye. It was almost seven weeks before he put on skates again.

It appeared to South fans Tony was through with hockey. The South High School newspaper had him out the remainder of the year at least.

But they didn't reckon with this 16-year-old, with his determination to return to hockey—and to return as a goaltender.

"I always figured on coming back, and as goalie," Tony said. "I'll give it till next fall, and if I can't hack it, then I'll try to skate wing."

He finds his greatest difficulty—as a one-eyed goaltender—is on the high shots.

"I still can't get the angles right. And I don't always know where the net is," he said.

So far, he hasn't felt there has been any problem judging distances, although vision experts felt this would be a major handicap.

He did ask that it not be revealed which eye is glass, "so they won't all try to skate in on my blind side.

Tony Julin returned to the ice in January 1972 wearing a barred catcher's-type mask to protect his good eye. *Bob Schrank*, Minneapolis Star.

"I still keep my body the same way," Tony continued. "but just turn my head a little more."

The slight turning of the head isn't evident under the "cage" he wears—a barred catcher's-type mask he wears on the ice to make sure nothing can get at his good eye.

His coach, Jim Salwasser, isn't surprised that Tony is back.

"He always had a lot of courage, and his attitude was always good," said Salwasser. "He doesn't want any special breaks. He told us that right away. He just wants to play. And I'll give him a fair chance.

"He is a quiet kid, in fact so quiet you almost think he's lethargic—until it comes to stopping the puck.

"And he stopped them today. They [the Hill-Murray players] didn't know which eye it was."

Tony had been involved in South hockey for less than a year before the injury, after attending De La Salle for ninth grade. Tony transferred to South and thus wasn't eligible in his sophomore year until last January.

This year, as a junior, he was battling senior Rick Rogers for the South goaltending job.

"They were pretty even at the time of the accident," Salwasser said.

Tony had slipped off his mask before a skating drill, he said. Then he went back into the nets as some teammates finished some one-on-one drills. Down on one knee, Tony said he batted one puck away, then the second caught him.

"A lot of 16-year-olds lie down and never try anything again," Salwasser said. "But Tony has never complained. And his teammates are behind him 100 percent."

FOLLOW-UP: In a 2010 interview, software engineer Tony Julin recalled in matter-of-fact tones the day he lost his eye in a practice at Met Center.

"We were doing two-on-ones, and I didn't have my mask on," he says. "A guy took a shot, and it was a low shot I had to kick away. As soon as I turned my head to get up again, there was another shot about two inches from my eye."

He knows who took the shot—"it was a guy I played hockey with for years"—but he wasn't angry with the shooter and doesn't hold a grudge against him.

Instead, "I was pissed off at the coach for not supervising and letting two guys shoot at the same time. For a while I was real pissed off."

As a goalie who has never stood in front of shooters without a mask on, I had to ask: where was Tony's?

"We were just doing skating drills, and I just didn't happen to have my mask on," he says.

It wasn't unknown for a goalie to remove his mask at practice in the early 1970s. Until the 1960s, few high school goalies even used one.

"Whether or not I had a mask on, it wouldn't have made a difference," Tony says his doctor told him after seeing the fiberglass mask he had been using. "The shot hit an inch above the orbital bone. The [eye opening of the] mask I had at the time was at the edge of the bone."

What made him decide to get back in the crease?

"I love playing hockey," he says, using the present tense even though it's been twenty-some years since he has strapped on the pads. "It's the greatest sport there is. Especially when you're a goalie. You're out there all the time, you're the center of attention. When you make a save, the crowd cheers."

His parents backed his decision to return to the ice. "My parents were supportive of whatever I did," he says, adding that he would do the same for his own children.

His high school career ended not long after the scrimmage against Hill-Murray. With one eye, he had difficulty tracking the puck and anticipating plays that developed on his blind side.

"I just couldn't play," he says. "Maybe I could have hung around and been a part of the team. But I just couldn't perform at the standard I set for myself. It just wasn't working out."

He did get back on the ice a few years later, playing in bar leagues after graduating from high school. "It was a lot of fun," he says. "We actually made it to the championship in Owatonna one year."

He hasn't played hockey since moving to Arizona in the 1980s. But he stays active. "Right now mostly I do a lot of bicycling," he says. "In Phoenix there's a huge mountain park, so I do a lot of hiking. Also, I coach my son's football team."

He says some good came of the accident that cost him his left eye. Not long afterward, hockey associations in Minnesota began requiring all players to wear eye protection. And goalies at every level now must wear standardized masks.

SPELLING CHAMP DRAWS A BLANK

JUNE 8, 1972 MINNEAPOLIS TRIBUNE

Terry Walfoort Jr. of St. Paul won the 1972 Upper Midwest Regional Spelling Bee. The Minneapolis Tribune, *which sponsored that competition, assigned a reporter to cover the eighth-grader's efforts on the national stage.*

ST. PAUL BOY OUT OF U.S. SPELLING BEE
WASHINGTON, D.C.

A 14-year-old St. Paul boy was eliminated in the third round of the national spelling bee contest Wednesday when he stumbled on the word "pirouette."

Terry Walfoort Jr., son of Mr. and Mrs. Terry Walfoort of 614 Fountain Pl., became one of 79 finalists when he won first place in the annual Upper Midwest Spelling Bee. The regional competition was sponsored by the *Minneapolis Tribune*.

Terry, an 8th grader at Sacred Heart–St. John School, said afterward that yesterday's competition involved "lots of hard words. Lots of French words."

He added, "I sort of feel that the real victory was winning the regional. Course all the losers say that, I guess."

Terry was accompanied to Washington by his father and his teacher, Sister Marina Mardian.

Sister Mardian said that Terry had spelled "pirouette" correctly before. But, she said, "You know how you sometimes blank out." Terry incorrectly spelled the word "pirhouette."

FOLLOW-UP: Terry Walfoort, now fifty-seven, is a driver at FedEx, where he has worked for the past twenty-nine years. He and his wife, Tracy, live in Cambridge, Minnesota. Between

Terry Walfoort Jr. won the first-place trophy at the Upper Midwest Spelling Bee, held at the Pick-Nicollet Hotel in Minneapolis in April 1972. *Powell Krueger,* Minneapolis Tribune.

them, they have five adult children. I interviewed him by phone in June 2009.

How did he get involved in the spelling bee back in 1972? The eldest of twelve children in his family, he loved to read—everything from Mad magazine to Edgar Rice Burroughs and the classics—and he fared well in spelling tests given by Sister Marina, who was looking for potential contestants.

"Others did better, but passed up the chance," Walfoort said. "I was willing to go ahead and give it a try."

That meant studying words for about thirty minutes a day, three or four days a week, before heading outside to play baseball.

The practice (and a lot of help from Sister Marina) paid off. He was thirteen when he won the regional tournament at the Pick-Nicollet Hotel in Minneapolis that spring. Then on to Washington, D.C., for the trip of a young lifetime: His first ride on a jet plane. A stay at the posh Mayflower Hotel, where the competition was held. A visit to the White House, where he met one of President Richard Nixon's daughters. And a stop at the FBI, where bee contestants watched agents demonstrate a tommy gun with live ammo. Walfoort still has one of the targets used that day.

Was he nervous when his turn came at the national bee?

"Absolutely," he said. "You're on that stage, in front of a microphone...You're praying that you get a word you're familiar with."

Does he remember the word he missed in the third round?

"I sure do. The word's pirouette. For some reason I had it in my head that it was like silhouette."

So can he spell it now?

Yes, but first he politely asked if I was ready. I typed his response one letter at a time.

"P – I – R – O – U – E – T – T – E. Pirouette."

He didn't ask if he was right. Thirty-seven years later, he knew it cold.

WORLD WALKER VOWS HE'LL FINISH TREK

DECEMBER 5, 1972 MINNEAPOLIS TRIBUNE

On June 20, 1970, two Minnesota brothers set out to walk around the world. Thirty-year-old David Kunst, a part-time movie projectionist, and twenty-three-year-old John Kunst, a newly minted University of Minnesota graduate, stepped onto a Waseca highway with $1,000 and a pack mule named Willy Makeit and headed east.

Their goal, in part, was to raise money for UNICEF, the United Nations Children's Emergency Fund. Mostly, though, they were seeking adventure and a place in the record books. In their first year on the road, they covered more than 3,500 miles, walking at a steady 4 miles per hour through eight states, Portugal, Spain, France and Italy. They met Princess Grace of Monaco and the Norwegian explorer Thor Heyerdahl. Generous strangers fed and sheltered them.

"It wasn't long after we started the walk that we realized if we finish, it would be because of people along the way who helped us," David Kunst said in a June 1971 interview in the Tribune's Picture Magazine.

Two years and more than six thousand miles into the trek, tragedy struck. Armed bandits attacked the brothers' roadside camp in foothills near Kabul, Afghanistan. John was shot to death; David was wounded and left for dead. David returned to Minnesota to bury his brother and recover from the attack. In the interview republished here, with Tribune *columnist Robert T. Smith, the surviving brother talked about the attack and vowed to continue the walk.*

Joined by his elder brother, Peter, he returned to the spot of the attack and resumed the walk. Together, they walked across Pakistan, India and part of Australia. At that point, Peter had to return to work in California. Continuing alone, for the most part, David

Above: John (left) and David Kunst shared a horse laugh with their second mule, Willie Makeit II, as they hoofed through France in April 1971. Star Tribune *archives*.

Left: John Kunst was shot to death by Afghan bandits in October 1972. *Donald Black*, Minneapolis Tribune.

completed the journey on October 5, 1974. The 14,450-mile walk earned him a place in the Guinness Book of Records *as the first person documented to have walked around the world.*

This familiar logo, sans headline, topped Robert T. Smith's popular metro column throughout the 1970s.

His brother lay murdered next to him. He was lying on his face, bleeding badly from a bullet wound in his lung.

The bandits grabbed his left arm and raised him up to see if he were dead. Then they dragged him by the feet to the wagon and threw a blanket on him.

"I swore everybody in the world could hear my heart pound," said Dave Kunst, 33, who returned to Minnesota Monday after Afghanistan marauders interrupted the walk-around-the-world project to aid UNICEF.

But, unlike the story books, Dave's life did not pass before his eyes and, although a Roman Catholic, he did not think of God.

"Survival, that was it," he said. "I said to myself, 'I've got to live because I've go some more living to do.'"

Dave and his brother, John, 25, both of Waseca, Minn., had traveled more than half way around the world—had done it all by foot except for ocean areas. They were ambushed in a deep gorge in the mountains of Afghanistan.

[Dave] talked about the ordeal Monday after he arrived in the Twin Cities on his way home. He was greeted by friends and relatives at Minneapolis–St. Paul International Airport. His father yesterday turned over to UNICEF donations totaling $1,200 received since John was killed. A UNICEF official said another $1,000 had been sent to the organization's office in Minneapolis.

John was killed by two shots from the six native bandits—the second shot administered after he fell wounded. To make sure. Dave was downed by a rifle shot, but immediately shouted to John: "Play dead."

"Once I said that I didn't think of John anymore until later," said Dave. "People talk about heroics, but I figure most of those people haven't been shot in a wild, foreign country with no one near to help."

The bandits ransacked the Kunst brothers' wagon. They took anything that they could use or sell. As they chatted and threw things about, Dave lay still under the blanket.

The bandits apparently figured Dave was dead, and after about 30 minutes they left. Dave struggled about 50 feet to the highway and knelt by the side of it.

"I was too weak and too much in pain so I couldn't stand," he said. "I tried to wave down trucks and caravans."

But no trucks stopped. One caravan of nomads paused temporarily and then continued on.

"I started to laugh," Dave said. "I knew they wouldn't stop. I knew they feared me, thought I was some decoy for a bunch of bandits."

David Kunst's face showed the wear of four years on the road during a stop in Nebraska in September 1974. *Kent Kobersteen,* Minneapolis Tribune.

Dave went back to the camp and tried to get on the brothers' mule. But the mule, either frightened or stubborn, wouldn't cooperate. Then he led the mule to the middle of the highway to force trucks to stop. But they just drove around the animal.

The shooting happened about 6 p.m. Oct. 21. At 3:30 a.m., Dave still was kneeling by the side of the highway. It was then a police patrol arrived.

They took him to an American dispensary in Kabul. He had lost a lot of blood and his left lung was almost collapsed. It was two weeks before he felt like walking across a room.

Dave is planning to rest up and then continue the walk. He is looking for another partner and plans to ask his other brother, Peter, 35, San Francisco, Calif., if he would join him.

"I'm going to make it," said Dave. "For John."

KICKS DISMANTLE
THE MIGHTY COSMOS

AUGUST 15, 1978 MINNEAPOLIS TRIBUNE

The Minnesota Kicks played in the North American Soccer League from 1976 until 1981, drawing an average of twenty-four thousand fans per game to Met Stadium in Bloomington. Professional soccer was new to Minnesota; many fans came largely for the tailgating and Frisbee-tossing in the big parking lot surrounding the stadium at Cedar Avenue and I-494. The Minneapolis Tribune *was new to soccer as well, as evidenced by the misspelling of Charlie George's first name and errant references to players in the "crease" in the story below.*

The star-studded Cosmos of New York were heavily favored to beat the Kicks in the second round of the playoffs in 1978. I passed up the chance for a free ticket that night. It was hot and humid, and frankly, I didn't have the heart to watch Minnesota lose again to Chinaglia & Co. I missed the high point of the season. Forward Alan Willey scored a jaw-dropping five goals for the home team. "It really was a spectacular effort by Willey," recalled his teammate Alan Merrick in a 2016 interview. "To do it against such a renowned team like the Cosmos makes it even more special and unique."

The season's low point came two nights later, when the Cosmos recovered to crush the Kicks 4–0 in game two in Giants Stadium, and then advanced with a 1–0 shootout win in the minigame that followed.

Kicks Overwhelm Cosmos 9–2
Willey Drills Five; Scoring Records Fall

By Bruce Brothers
Staff Writer

The Minnesota Kicks destroyed the defending champion Cosmos 9–2 Monday night at Metropolitan Stadium, riding the five-goal gunnery of Alan Willey to triumph in the first of a two-game NASL play-off series.

"They just overpowered us," said Cosmos Coach Eddie Firmani.

Numerous records fell as the Kicks vented their 1978 scoring frustrations before a delighted gathering of 45,863, whose spirits

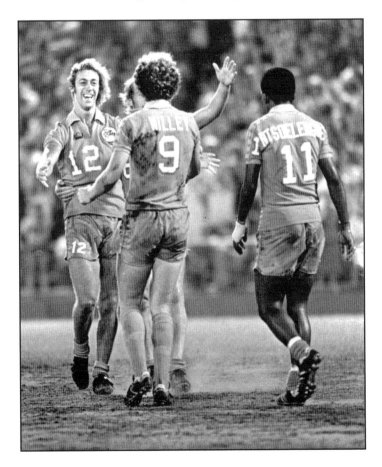

Charlie George, Alan Willey and Ace Ntsoelengoe congratulate one another after the 9–2 victory over the Cosmos. *Tom Sweeney,* Minneapolis Star.

remained undampened by a thundershower in the final minutes of the one-sided match.

The victory sends the Kicks to Giants Stadium, the Cosmos' home in East Rutherford, N.J., with the upper hand for Wednesday's second game. Two victories are needed to advance in the play-offs. Should the Cosmos win tomorrow, an overtime "mini-game" will follow to decide which team will go on to the conference championship against either Vancouver or Portland.

"After tonight's performance," Willey said, "there is no way we can get beat Wednesday."

Willey's five goals set an NASL play-off record, while the nine Kicks' goals was a playoff record as well as the team's three-year high. And Charley George, who scored with 52 seconds gone in the game, got a play-off record for the fastest goal.

"I knew the chances would come," Willey said, "because they did in the first game [a 4–2 Cosmos victory] and we didn't put them away. We put them away tonight. There is nothing we can do wrong now. We've been threatening to score a bunch against somebody, but I didn't think it'd be the Cosmos. It feels good, especially against the Cosmos, because they're the team to beat."

From the first minute the Cosmos were struggling. Tony Want's crossing pass to George found the Minnesota striker and Cosmos goalie going high for the ball in the crease. [Erol] Yasin crumbled to the turf after their collision and the ball bounced off George's body and into the net. Not only Yasin's pride was hurt. He had to leave the game with a slight concussion.

The Kicks' outlook got even brighter 17 minutes later when Cosmos Captain Werner Roth tried to clear a corner kick off the foot of Chico Hamilton. Roth drilled the ball behind a startled Jack Brand, the Cosmos' backup goalkeeper.

The own goal was especially cheering to Kicks' goalkeeper Tino Lettieri, who has been victimized by a couple of them this season. "That second took a bit of tension off our minds," Lettieri said. "Scoring two goals is good, the confidence builds and you just want to score more."

Willey's first goal at 29:28 made it 3–0 at half time, but the Cosmos came back on Giorgio Chinaglia's drive past Lettieri three minutes into the second half. The Kicks needed just five minutes to retaliate, however, thanks to some sloppy defensive work in front of the Cosmos goal.

George was alone in the crease and Roth found himself confronted on the other side by two other Kicks. George slid the ball of Roth's foot to Ace Ntsoelengoe, who put it away for a 4–1 score.

Ntsoelengoe, who suffered a cut hand but said it isn't bad, said the Cosmos do not seem to play as well when they have to come from behind. "They are

Alan Willey sported a new perm for the 1978 season. Star Tribune *archives.*

one team," he said, "that when you get two or three goals on them, they go down."

"When we scored that fourth goal," George said, "that did it."

Goals came hot and heavy after that, keeping the big crowd in a happy frame of mind despite the 90-degree heat. Willey got three in a row, at 62:28, 69:05 and at 77:27. The Cosmos finally scored again when Gary Etherington booted in a shot with 6½ minutes remaining, but Willey drilled another one minute later and Chico Hamilton added the ninth in the final minute.

The nine goals was the most ever yielded by the Cosmos, who also had a seven-game play-off winning streak ended by the onslaught.

"I thought we just played badly," said Firmani.

Willey pronounced the game his best ever. "I've had nothing as good as that," he said. Said George: "They'll be ready Wednesday, but this game should do a lot for us. If it doesn't I don't know what will."

"What can you say, it was unbelievable," Kicks Coach Freddie Goodwin said. "Bearing in mind the occasion, what was needed and the opposition, it was an outstanding performance. Now, on Wednesday, we've got to go out and play the same way."

Quick Kicks: Dennis Tueart of the Cosmos collided with Lettieri early in the game and left later with a bruised thigh...George got a knock on his injured foot, but said after the game that the foot is OK...The Kicks outshot the Cosmos 31–12. Chinaglia, the league scoring champion with 34 goals during the season and two more in the play-offs, had six of the losers' shots. Willey had 10 shots... Lettieri got an assist on Willey's final goal, throwing the ball to Hamilton, who brought it down and crossed to Willey in front...Hamilton had three assists in addition to his goal...Rookie Alex Rosul, the Kicks' first-round draft choice this year, got an assist on Willey's fourth goal, his first-ever in the NASL.

ACROSS THE ATLANTIC IN A 10-FOOT SAILBOAT

JULY 24, 1979 MINNEAPOLIS STAR

In 1977, Gerry Spiess began building a ten-foot plywood-and-fiberglass sailboat in his garage in White Bear Lake. Spiess, a technical instructor at 3M Company, had designed and built other boats and was an experienced sailor. He had sailed down the Mississippi River and crossed the Gulf of Mexico to South America. But two attempts to sail around the world were scuttled by illness and bad weather.

He designed little Yankee Girl to set a world record as the smallest boat to cross the Atlantic Ocean. The 750-pound vessel was equipped with four sails (main, two jibs and a spinnaker), a fourteen-foot aluminum mast, a self-steering mechanism, a VHF radio, navigational gear, a four-horse Evinrude outboard motor and sixty gallons of fuel.

Without a soul to see him off, Spiess set sail from Virginia Beach, Virginia, on June 1, 1979. The little sloop was loaded with provisions, including beef jerky he and his wife, Sally, had made in their kitchen. To stave off boredom and loneliness on the 3,800-mile journey, he packed books by Mark Twain and recordings of old radio programs. One of his regrets: he did not bring a good pillow.

In fifty-four days at sea, he survived close encounters with a passing ship, a school of whales and a circling shark. Pounded at times by twenty-foot waves and forty-knot winds, Yankee Girl was a speck on the ocean, barely visible on radar. For one seventeen-day stretch, he had no contact with the outside world. "If anything had happened to me during that time," he later wrote, "no one would have known in what area of that gigantic ocean I was."

Thousands of well-wishers greeted Spiess upon his arrival in Falmouth, England.

"I did have some bad moments, but I'm absolutely delighted to have made it at last," he told reporters. "I wouldn't do it again, or advise anybody to do it. The first two weeks were sheer hell."

He did not do it again. Instead, two years later, the White Bear Lake sailor climbed aboard Yankee Girl *and set out to conquer the Pacific Ocean. He made the 7,800-mile crossing, from Long Beach, California, to Sydney, Australia, in 153 days. His tough little boat was donated to the Minnesota Historical Society in 1984.*

English Port Welcomes White Bear Solo Sailor

By Brenda Ingersoll and Peter Ackerberg
Minneapolis Star Staff Writers

Sally Spiess visited her husband, Gerry, early this morning.

It wasn't an ordinary get-together.

Spiess, 39, White Bear Lake, was about to set a world record by completing an Atlantic crossing in a 10-foot boat, the smallest ever to complete the voyage. Spiess appeared in good health, despite being swept overboard in the early days of his voyage.

Mrs. Spiess was in a pilot boat off the Falmouth, England, harbor when she got her first glance at Gerry in 54 days. He set sail June 1 from Virginia Beach, Va., in "Yankee Girl," the boat he designed and built in his White Bear Lake garage.

United Press International reported that Spiess edged Yankee Girl close to the towering 40-foot Falmouth pilot launch Link, to talk to his wife and his parents, Louis and Jeanette Spiess of St. Paul.

His mother looked down into Yankee Girl and said, "Let me congratulate you. Your housekeeping looks superb, the boat looks clean and tidy—you must have had a nice trip."

Spiess, sporting a beard after his long trip, gave a tired smile, and said, "That's only half of it. The first two weeks were sheer hell."

Spiess said 20-foot waves had pounded his boat creating "valleys in the ocean which almost enveloped us."

He said he was swept overboard one day early in the voyage.

"I was saved by my lifeline. It held fast. I gave a tremendous pull and managed to haul myself back on board Yankee Girl.

"It was a terrible half hour. I knew I had to make it back to the boat. I never had any worries after that. What could have been worse?"

Gerry Spiess, back home with *Yankee Girl* after his Atlantic crossing. *Charles Bjorgen,
Minneapolis Star.*

But Mrs. Spiess told The *Star* in a telephone interview that although she was
concerned for her husband's safety throughout the trip, "I was eased by the fact
that I know the man that built that boat and the years of effort and study he put
into its construction. I never considered myself a potential widow."

He looks fine, she said. "He's grown a beard since I last saw him. He's lost
a little weight—in fact he's thinner than I've ever seen him.

"I'm sure he's looking forward to stepping on land. His immediate request
was for a steam bath."

Plans for the future are "completely up in the air at this point," she said.
"We'll stay in England for a week to 10 days."

A flotilla of boats flying the U.S. flag and blowing horns flocked around
Spiess's boat about a mile from shore at 11 a.m. today. Residents of Falmouth
were preparing a gala reception for Spiess at the Royal Yacht Club.

Spiess designed his wood-fiberglass boat "for the optimum food and water
carrying capacity," his wife said. "He brought a lot of tinned food, granola
and beef jerky, which we prepared at home in our kitchen.

"He also took much tinned milk, dried fruit and, in the beginning, he was able to carry fresh fruits and vegetables as well."

The six-foot-wide boat has a narrow bunk, a small chart table, a tiny galley and an emergency four-horsepower motor.

The boat has a self-steering mechanism that kept it on course while he slept.

Mrs. Spiess, assistant branch manager at Analysts International Corp., Edina, said the second worst time of her husband's trip occurred "last night when he was in the heavy shipping lanes. He has a radar reflector (to alert other craft of his presence), but last night he did not sleep. He wanted to get out of the shipping channel."

The final hours of Spiess' journey were described by a British Coast Guard official as among the most dangerous of the voyage because shipping lanes approaching the southern coast of England are crowded with tankers and freighters. Visibility was only one-half mile last night.

"He likes a challenge, and he's dreamed about this for quite a while," said Bill Mezzano, a friend of Spiess who used to work with him at the 3M Co.

Spiess, 38, who had been a technical instructor at 3M, left the company early this year to prepare for the voyage, Mezzano said.

"He's not doing it for the publicity, he's not doing it for anybody but himself," Mezzano added.

Spiess avoided loneliness on his voyage by taking several volumes by Mark Twain, a tape-recorder and recordings of radio shows.

"I realized how unpleasant it was to go alone," Spiess said in 1970 after a sailing trip in the Gulf of Mexico. "There is nothing lonelier than a week or so at sea in a small boat. Some people can be alone for long periods of time, but I guess I'm not one of them."

The Spiesses, who have been married almost 17 years, "have always sailed," Mrs. Spiess said. Spiess has built four sailboats, three of his own design. He has tried twice to sail around the world. One voyage was halted because of bad weather, the other because he got sick.

Spiess left on his latest trip with instructions to his wife not to worry until 90 days had passed. He predicted the crossing would take 60 days under favorable conditions.

The 1979 *Guinness Book of World Records* lists a 12-foot boat as the smallest before this to cross the Atlantic west to east. That boat, the Nonoalca, captained by William Verity of the United States, went from Fort Lauderdale, Fla., to Tralee, Ireland, in 66 days in 1966.

AHMAD RASHAD'S "MIRACLE CATCH"

December 15, 1980 *Minneapolis Tribune*

Where were you when Tommy Kramer led the Vikings to an astonishing comeback over Cleveland at Met Stadium on a chilly December afternoon more than thirty-five years ago? A former colleague at the Star Tribune *recalled that she and her dad were listening to the game on the car radio and that he pulled over on Franklin Avenue after Ahmad Rashad's winning catch so that they could jump up and down in celebration. I, too, was listening on a car radio, running solo errands in the same part of Minneapolis. I let out a whoop but didn't stop the Pinto wagon or even honk its horn, though I distinctly remember hearing many others honking theirs.*

Minutes later, the Tribune*'s Joe Soucheray was in the visitors' locker room at the Met, gathering fodder for this page-one account of the "miracle catch."*

It appears that the Tribune *sent only one photographer and two reporters—not counting Sid Hartman—to cover a home game that had playoff implications. Nowadays, such a game would draw three times as many staffers, with or without Brett Favre wearing purple.*

By winning the NFC Central and advancing to the playoffs with this victory, each Viking pocketed an extra—wait for it—$5,000.

VIKINGS WIN TITLE AGAIN, BUT…IT WAS NO LESS THAN ASTONISHING

By Joe Soucheray
Staff Writer

Maybe we have become too cinematic with this game of football and all its pretentions, but Sunday afternoon at Metropolitan Stadium the ball seemed

With six seconds showing on the scoreboard clock, Vikings running back Ted Brown raced up the sidelines after taking a lateral from tight end Joe Senser. The thirty-four-yard hook-and-ladder play moved the ball to the Cleveland forty-six yard line and gave the Vikings time for one more play. *Charles Bjorgen,* Minneapolis Star.

to travel its arc through onrushing dusk as though in slow motion. There aren't many moments like it, when the season is on the light end of the scale and the football is sailing through the air to upraised hands in the end zone and thousands of cold and disbelieving fans have stopped in their tracks to the exits.

The Vikings trailed Cleveland by a point, 23–22, and Tommy Kramer had just launched a pass from the Browns' 46-yard line into the right corner of the end zone, with four seconds showing on the scoreboard clock. Terry LeCount, Ahmad Rashad and Sammy White had been deployed to the right corner, LeCount in the middle as if it had been a wing formation. The clock ticked down to zero with the ball in flight. The Browns had responded by sending out a fleet of six deep backs, most principally Thom Darden, the eight-year safety out of Michigan.

"I chose to stick with White," Darden said later in his locker room. "I am sure the ball was intended for White to tip to Rashad. In my mind White was the tip man and I wasn't going to permit it."

"Where was Rashad?" somebody said.

Wide receiver Ahmad Rashad hauled in Tommy Kramer's pass after it was tipped by a defender near the four yard line. *William Seaman,* Minneapolis Star.

"At that point I was between White and Rashad," Darden said. "Suddenly, White stopped. When he stopped, I stopped. And when he went into the air I went with him. I did get a hand on the ball."

"Where was Rashad now?" somebody said.

"By now he was in the vicinity," Darden said.

Rashad caught the ball, on what the Vikings insist was a tip off White's fingers. Rashad was near the 2-yard line and he backed in, victorious in this astonishing and totally unlikely game of volleyball that had given the Vikings a victory and yet another Central Division championship. It was almost a replay of the ball Drew Pearson of the Cowboys caught in the shadow of Nate Wright at the Met in a 1975 first-round play-off game.

"I wasn't going to allow Sammy to tip the ball, much less catch it," Darden was saying. "And I ended up tipping it to Rashad. It did not occur to any of us—me or Rashad or White—what had happened until we heard the crowd reaction."

In the Cleveland locker room later there was an occasional curse. Dirty laundry was flung this way and that. A television newsman discovered Cleveland coach Sam Rutigliano in the corner of the bathroom.

"Can we get a live interview?" the TV man said.

"How can you?" Rutigliano said. "I'm a dead man."

Rutigliano was more than gracious, almost bemused by what had just happened. He couldn't for the life of him remember Darden as his primary defender on the miracle catch.

"It was great concentration by a great player," Rutigliano said of the catch. "It was a 30-foot putt and he'll never make it again, but it was memorable. Neither team got much pressure to the quarterback today and the quarterbacks proved resourceful, didn't they?"

"Are you as cool on the inside as you appear on the outside?" Rutigliano was asked.

"I don't know," he said. "You'd have to perform an autopsy."

As interesting as the miracle catch—or more accurately, as astonishing—was a Brian Sipe pass intercepted by Bobby Bryant minutes earlier in the fourth quarter. Cleveland held a 23–15 lead with nearly five minutes left in the game and the Browns were cruising upfield when Sipe chose to pass on a second-and-nine from his own 41 yard line. The pass was intended for Reggie Rucker.

"That was an option screen play," Rutigliano said. "It worked well for us earlier in the game. We were thinking first down. We were thinking ball possession. I had warned the team at half time that the Vikings were an extremely patient team."

"Were you surprised that Sipe passed at that point?" [Vikings coach] Bud Grant was asked.

"Not at all," Grant said. "They've always used the short pass as a form of ball control. Bobby Bryant just cheated a little. He knew that Sipe wouldn't throw deep and he moved in front of Rucker."

"Rucker was the intended receiver," Sipe said over in his quarters. "But in retrospect I wish I would have dumped it off to Cleo Miller, which was my option on the play. But hey, even after that I didn't think we were in trouble."

But the Vikings struck quickly with a touchdown to Rashad. Cleveland got the ball back and eventually punted, giving Minnesota its final possession at the Minnesota 20-yard line with 14 seconds left in the game. The play that moved the team downfield was a pass to Joe Senser and the subsequent lateral to Teddy Brown, a play that moved the ball from the Viking 20 to the Cleveland 46, from where Kramer struck with the miracle throw.

"A flea flicker is what beat us as much as anything," Calvin Hill said afterwards. "A damn good flea flicker, that Senser-to-Brown play."

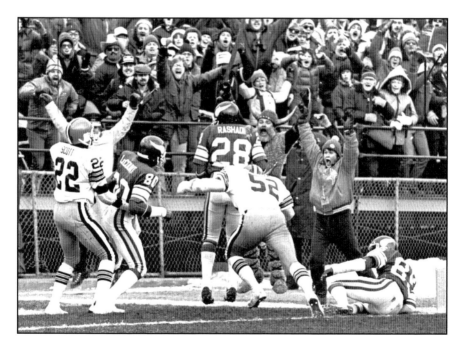

Rashad, untouched, backed into the end zone to score the winning touchdown. *William Seaman*, Minneapolis Star.

But it was the catch that people will remember, one of those great moments in sports that can be called up in the mind and played over and over again. It did take the chill off a winter day, all that heat and passion boiled down to the final play of a football game.

KIRBY PUCKETT ARRIVES

May 8, 1984 *Minneapolis Star and Tribune*

Twin Cities newspapers were full of interesting nuggets during the week that Kirby Puckett, then twenty-three, found his way to the major leagues. Gymnast Nadia Comaneci retired at age twenty-two. The Soviet Union announced it would boycott the Olympics in Los Angeles that summer. A fellow named R.T. Rybak was covering business news. Gloria Steinem, appearing in the Twin Cities for a lecture on women's issues, predicted that 1984 would not be the year that a presidential candidate would choose a woman as his running mate. And a movie called The Natural *opened in local theaters.*

Puckett made his major-league debut for the Twins on May 8, 1984, going four for five in a 5–0 victory over the Angels. His debut would have come a day earlier but for some unexpected delays. Reporter Jay Weiner explained:

New Twin Ends Up Playing for Time

By Jay Weiner
Staff Writer

Anaheim, Calif.—For a fresh-cheeked rookie, Kirby Puckett, just 23, has seen the world.

Unfortunately, the newest Twin saw it all Monday, the day he was supposed to make his major league debut.

"Where's Punkett?" Twins Manager Billy Gardner said with characteristic mispronunciation soon after the 5 p.m. team bus arrived at Anaheim Stadium. "He didn't go to Dodger Stadium, did he?"

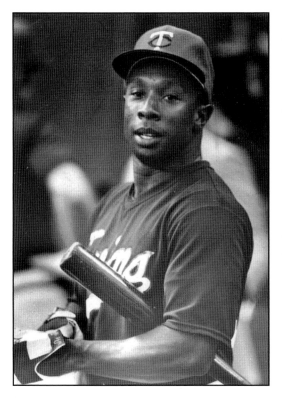

A trim young Kirby Puckett prepared to take an at-bat in his first week in the major leagues. *William Seaman, Minneapolis Star Tribune.*

The uniform, No. 34, was there. Even the neatly stitched "P-U-C-K-E-T-T" on the back of the Twins' blue road jerseys. That name, with just two seasons plus 19 games of minor league experience, was to have been in center field, batting first against the Angels last night.

"When they draft you into the Army they put you at the front lines, right, pal?" Gardner said.

Right. But it was already 6 o'clock, the Twins were due for batting practice and, still, no Puckett, the 5-foot-8, 185-pound fire hydrant who has been compared with former Houston Astro star Jim (Toy Cannon) Wynn.

Twins Traveling Secretary Mike Robertson was getting worried.

Puckett's plane from Portland, Maine, where the Triple-A Toledo Mud Hens played Sunday, was due at Los Angeles International Airport soon after 1 p.m. With the hour drive south to Orange County, the righthanded hitter was long overdue.

At 6:10, Puckett, carrying his equipment bag, raced through the door.

"I got to get some money, man," he said to Robertson. "I got to pay the cab."

"I had to take one," he said later, apologetically. "It was eighty-three dollars...I was stunned."

He first got the bad financial news as he was driving along the freeway. He first heard $74. But when he realized it was so late he couldn't stop at the hotel, he told the cabbie to proceed straight to Anaheim Stadium.

"He said, 'Since you're not going right to the Hyatt, I'll have to charge you more,'" Puckett reported.

It was a ridiculously fitting end to a ridiculously tiring day.

The no-necked native Chicagoan, who was hitting .270 with eight stolen bases in the International League, began his day at 5:30 a.m., Eastern time, or 2:30 a.m. California time. He made it to Atlanta from Maine just fine, but when he switched planes, the new aircraft, bound for Los Angeles, had to have its windshield changed.

"Twice," Puckett said. He was delayed four hours. "They said it was cracked… and the defroster didn't work…I couldn't believe it.

"Nice start, huh?"

Not really. There was no start at all. Gardner decided Puckett was too tired to play. Darrell Brown started instead.

"I think," said Gardner, "the kid needs a rest."

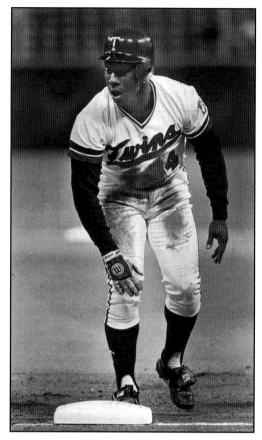

Right from the start, Kirby Puckett didn't miss a chance to get his uniform dirty. Star Tribune *archives.*

ABOUT THE AUTHOR

B en Welter, former news copy chief at the *Star Tribune*, is a Minneapolis native and University of Minnesota graduate. He has been reading newspapers since his first grade teacher, Sister Romana, taught him how to say the alphabet backward and forward in 1965. Forty years later, he began scouring his paper's microfilm in search of interesting stories and photos dating back to 1867. He has posted more than six hundred of the best on his blog, "Yesterday's News" (www.startribune. com/yesterday). To avoid dating himself, he established one rule at the blog's launch: stories published during his own lengthy newspaper career do not qualify as "Yesterday's News." He has broken that rule just once, posting an account of Twins legend Kirby Puckett's exhausting first day in the Big Leagues in May 1984.

Your comments, memories and suggestions are welcome at www. startribune.com/yesterday. Or follow him on Twitter (@oldnews).